BASICS

CREATIVE P

02

CONTEXT AND NARRATIVE

20·46

10/13

Short

academia

An AVA Book

Published by AVA Publishing SA
Rue des Fontenailles 16
Case Postale
1000 Lausanne 6
Switzerland
Tel: +41 786 005 109
Email: enquiries@avabooks.com

Distributed by Thames & Hudson (ex-North America)
181a High Holborn
London WC1V 7QX
United Kingdom
Tel: +44 20 7845 5000
Fax: +44 20 7845 5055
Email: sales@thameshudson.co.uk
www.thamesandhudson.com

Distributed in the USA & Canada by:
Ingram Publisher Services Inc.
1 Ingram Blvd.
La Vergne TN 37086
USA
Tel: +1 866 400 5351
Fax: +1 800 838 1149
Email: customer.service@ingrampublisherservices.com

English Language Support Office
AVA Publishing (UK) Ltd.
Tel: +44 1903 204 455
Email: enquiries@avabooks.com

ISBN 978-2-940411-40-5

Library of Congress Cataloging-in-Publication Data
Short, Maria.
Basics Creative Photography 02: Context and Narrative / Short,
Maria p. cm.
Includes bibliographical references and index.
ISBN: 9782940411405 (pbk.:alk.paper)
eISBN: 9782940447121
1.Photography.2.Photography--Study and teaching.
TR161 .S567 2011

10 9 8 7 6 5 4 3 2 1

Design: an Atelier project, www.atelier.ie
Cover image: Stuart Griffiths

Production by AVA Book Production Pte. Ltd., Singapore
Tel: +65 6334 8173
Fax: +65 6259 9830
Email: production@avabooks.com.sg

Title: The Portrait

Photographer: Maria Short

Placing a subject either in a
decontextualized setting or, as
in this case, in situ, can have an
impact on the interpretation and the
narrative within the image.

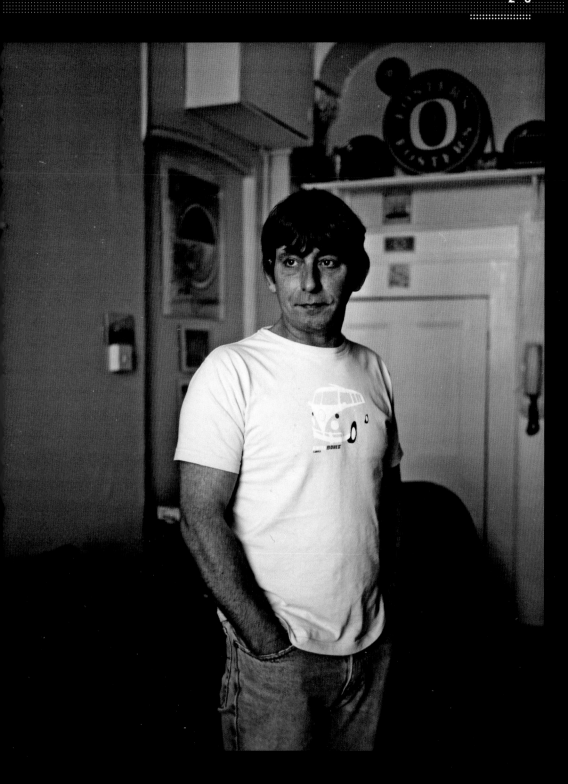

Contents

Most of us are surrounded by photographs; photographs with a myriad of roles and functions within and around our lives. There are photographs that encourage us to buy things, photographs that tell us of local and international news, photographs that show people and places, document events and provide evidence of what happened. In some cases, photographs may actually be the cause of creating a moment or an event. For some of us, photographs may be among our most treasured possessions.

Photographs tell us of the past; the past seconds, minutes, hours and years. Photographs can inform and contain memories. Photographs can aid and influence our identity and our relationship with others. Photographs can share ideas, concepts and beliefs. Photographs can distort the truth and reality; photographs can be highly subjective works of propaganda, they can be created and used responsibly or irresponsibly. As with many areas of communication, photographs can be a reflection of an individual's or a group's beliefs, ideals, dignity and integrity.

Defining context and narrative

The art of storytelling relies heavily on understanding the role that context and narrative play in relation to the medium in which it is told and to whom. How a story is told, whether visually or in words, is dependent upon time, culture and audience. We could say that this is context in its simplest form. Context can be described as the circumstances that form the setting for an event, statement or idea. In photography the word 'context' can relate to the contents of the photograph, its placement in relation to words or other images, the publication or place in which it is viewed and the broader photographic, social, cultural, historical and geographical context.

The word 'narrative' means a spoken or written account of connected events, a story that can convey an idea. In using photography to tell a story or convey an idea, narrative techniques can be employed to build and develop the story, hold the attention of the audience and enable them to relate in some way to the story and its intention. A story told through photography can exist as a single stand-alone image or as a series or set of images. Therefore, the context and narrative of a photograph can work in a variety of ways to enable effective visual communication.

Making 'successful' images

So, what makes a successful photograph? Many photographers and artists alike have a tendency to be fairly intuitive in their image-making process, subconsciously using their visual awareness to create, technically produce and edit their work. If we look at context and narrative in terms of a structure or method and apply this to the process of producing photographic work, we can perhaps identify, to a certain extent, the significant ingredients behind a successful photograph.

This book addresses photography as a creative and academic endeavour and so, while it is possible to learn practical techniques and engage with theoretical debate, there is no prescribed formula. The creative, thinking photographer makes decisions regarding the appropriate application of techniques against the backdrop of a theoretical understanding based upon their personal approach to visual language.

The structure of the book

This book explores the concepts and mechanics behind the picture-making process in relation to context and narrative. It is for photographers who are intent on developing their approach to visual language.

The book is divided into chapters that demonstrate the interrelationships and overlap of some of these concepts and mechanics that are central to photographic practice and debate. The first three chapters highlight the three-way relationship between the photographer, the subject and the audience. By raising basic concepts surrounding notions of truth and reality, these chapters address the pertinence of context and narrative to the making and reading of a photograph.

Building upon the concepts raised in the previous chapters, the final three chapters specifically address the contextual and narrative mechanics of visual language; exploring how they can be used to produce coherent images.

The photograph

Chapter 1 explores the role and function of the photograph; its purpose and intention. We look at the photographic brief and discuss points to consider when either creating or responding to a brief and see how understanding context informs our decisions.

Subject

In Chapter 2 we consider choosing our subject matter for the photograph and how we research, prepare and relate to the subject before and during the photographic process and how this shapes our resulting photographs.

Audience

In Chapter 3 we examine the intention behind our photographs in relation to the audience and how presentation and image quality support that intention.

Narrative

In Chapter 4, through looking at a variety of examples, we discuss narrative techniques and explore their use in helping translate our ideas and concepts into photographs.

Signs and symbols

Chapter 5 introduces basic theory surrounding the use and reading of signs and symbols within photographs. We consider the use of signs and symbols as visual clues to help the audience interpret the image.

Text

Text can be the most significant tool we use with our photographs to support our intention. In Chapter 6, we explore the photograph as text itself, text within the photograph and presenting text with the photograph.

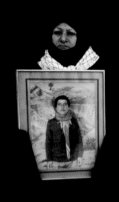
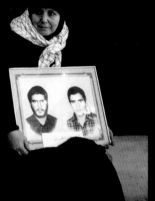

The photograph

Title: *from* 'Mother of Martyrs'

Photographer:
Newsha Tavakolian

Every Thursday and Friday, Iranian mothers who are proud that their sons have given their lives for Iran, visit the cemetery. Their sons died fighting Iraqi Republican Guards. They all cherish the portraits of their sons. This photograph is a clear example of how significant photographs can be to those who have lost loved ones. Tavakolian is a young, female, award-winning Iranian photographer. The main focus of her work is women's issues in the Middle East and her work has been widely published in the press internationally.

Essentially, photographs are always of the past. The moment happened or was created, it is photographed and then it is gone. These documented moments can be used in many ways and although they are of the past they can have a direct relevance to the present and encourage us to think of the future.

Photographs can be objects and they can be images; they can convey or inspire aspirations and even express thoughts, feelings and ideas that transcend historical and cultural differences. Photographs can create and evoke memories or simply depict the subject and be informative.

Successful photographs are a result of the photographer engaging, on both practical and conceptual levels, with a set of criteria relating to the context of the photograph and the brief. The brief should cite the function and purpose of the photograph and then the photographer works to fulfil that.

In this chapter, we will explore the use of photographs from the perspective of the photographer in order to illuminate key considerations when either working to a brief or producing self-directed work.

Debates concerning truth and reality have surrounded photography since its inception. The photograph has the ability to literally depict visual appearances but can also be subjectively, conceptually and technically constructed or manipulated to present a particular view or idea.

In 'The Heroism of Vision' from *On Photography* (1979), Susan Sontag describes: 'Many people are anxious when they're about to be photographed … because they fear the camera's disapproval. People want the ideal image; a photograph of themselves looking their best. They feel rebuked when the camera doesn't return an image of themselves as more attractive than they really are… In the mid-1840s, a German photographer invented the first technique for retouching the negative. His two versions of the same portrait – one retouched, the other not – astounded crowds at the Exposition Universelle held in Paris in 1855… The news that the camera could lie made getting photographed much more popular.'

As Sontag illustrates, the camera can lie, and this dynamic between a mechanical tool and its highly subjective use is central to photographic discussion in terms of the relationship between the photographer, the subject, the photograph and the audience.

The purpose and function of the photograph shapes and informs the approach of the photographer. Dependent upon the desired end result, the photographer will be required to engage with these 'levels of truth' in varying degrees, in both a practical and conceptual manner.

The following pages provide a brief over-view of some of the basic functions of a photograph in order to explore these 'levels of truth' in relation to different photographic approaches. By no means an exhaustive or definitive list, the groupings highlight basic points to consider when identifying some generalized functions of the photograph that will inform the photographer's approach in relation to notions of truth and reality. Underpinning the inter-relationships and overlap of these groups is the idea that the context in which the photograph is viewed will inform both the method of production and its interpretation.

The literal depiction of appearances

There are certain types of photographs whose main function is to depict or record the visual appearance of something, someone or some place. Passport photographs, product shots, medical imaging (such as X-rays or MRI scans) and scene-of-crime photography are the most obvious. In these circumstances, passport photographs aside, the photographer is required to be an expert in technical ability.

These photographs exist as evidence, so the viewer needs to see as much detail as possible. Therefore, the main thrust of the photographer's brief and goal is to produce high-quality images that replicate the original subject as closely as possible. To achieve this, the photographer makes choices dependent upon lighting, composition and the quality of the rendered image.

**Title: Sandy Springs Bank
Robbery (c. 1920)**

Source: Courtesy of
National Photo Company
Collection (Library of Congress)

A scene-of-crime photograph; note
the level of attention paid to exposure
and tonal quality, thereby allowing the
image to be as detailed as possible.

Beyond the recording of appearances

In *Camera Lucida* (1980), Roland Barthes writes about a photograph of his mother, taken when she was five. Barthes is in the apartment in which his mother died, looking through a collection of her photographs; looking for 'the truth of the face I had loved'. He finds the photograph, which contains aspects of his mother's character that he is searching for in the collection of photographs. In this search, Barthes articulates a way in which many of us relate to photographs; the manner in which they convey an aspect of the shared human experience and provide some form of tangible evidence or gateway to the existence of ourselves and others.

The manner in which the photograph can go beyond the recording of appearances and convey something of the individual's character or circumstances is something that we can relate to in both the production and sharing of our personal photographs. We may hold dear photographs of the deceased or from a time long past. Photographs may help confirm, or indeed even create, our sense of personal history and identity. We can use photographs to portray our identity; an identity that may be consciously constructed or simply revealed with a smile or gesture. Photographs can keep memories alive, but they can also create, distort or substitute memories.

Within our personal collection, we may also have other kinds of images that literally depict appearances; for example an MRI scan or an X-ray of ourselves, a relative or a pet. These images, originally produced for medical or factual purposes, can take on new meaning being viewed in the context of a personal possession; they can become part of their subject's identity and we may relate to them on a more emotional level. This illustrates the importance of context informing interpretation.

Levels of truth

A photograph can distort reality through:

· The photographer's intention or agenda: portraying the moment, person, place, event or idea in a particular way.

· The photographer's literal perspective: including/excluding relevant factors, composition and timing.

· The subject's intention: wanting to appear in a particular way, arranging their expression and physical gestures.

· The technical approach: format and the placing and presentation of the image.

· The value the audience attributes to the photograph: informative, intellectual, scientific, emotional and physical.

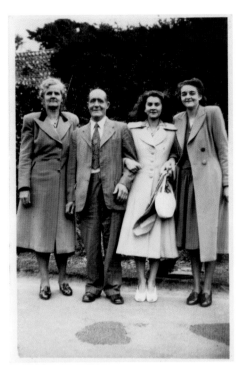

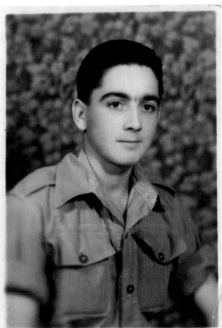

Title: A collection of family photographs

Photographer: Unknown

A collection of formal and informal family photographs that offer a gateway into the existence of ourselves and others.

Telling stories – truth or fiction?

Telling a story through photographs can take many forms and presenting or viewing an image in a particular context will inform how the image is read. For example, the British publication *Picture Post* (1938–1957) and the American publication *Life Magazine* (1936–1972) are famous for their photographic stories, frequently referred to as 'photojournalism' or 'documentary photography'.

Magnum photographer David Hurn talks about the connotations of these terms to Bill Jay in *On Being a Photographer* (1997): 'If I were called, or called myself, a documentary photographer it would imply, to most people in this day and age, that I am taking pictures of some objective truth – which I am not. … The only factually correct aspect of photography is that it shows what something looked like under a very particular set of circumstances. But that is not the same as the underlying truth of the event or situation.'

The terms 'photojournalism' and 'documentary photography', because of the nature and implications of the terminology, raise quite complex debates that relate to notions of truth and authenticity. As Derrick Price observes in 'Surveyors and Surveyed' from *Photography* (2004), edited by Liz Wells: 'Certainly the nature of an image itself is not enough to classify a particular photograph as in some essential way documentary; rather we need to look at the contexts, practices, institutional forms in which the work is set.'

Photography as social commentary

Karin Becker Ohrn offers a definition of the photographic documentary in *Dorothea Lange and the Documentary Tradition* (1980): 'The photographer's goal was to bring the attention of an audience to the subject of his or her work and, in many cases, to pave the way for social change.'

While a photograph may not be an objective depiction of reality, it can be a considered means of conveying what the photographer feels to be the spirit or essence of the idea, person, place or event. Social documentary photographs, while being rooted in the photographer's experience of the subject and shaped by their conceptual approach, can offer a visual experience of a set of circumstances in order to initiate, share or convey an understanding that goes beyond words.

The term photojournalism can imply a significant relationship with text, current events and the illustration of a news story. In simple terms, documentary photography and photojournalism can both refer to the photographic telling of a story with a particular intention.

The documentary or photojournalistic approach requires the photographer's involvement with the subject, a sense of responsibility toward the brief, subject and audience and the ability to negotiate with ethical issues surrounding photography.

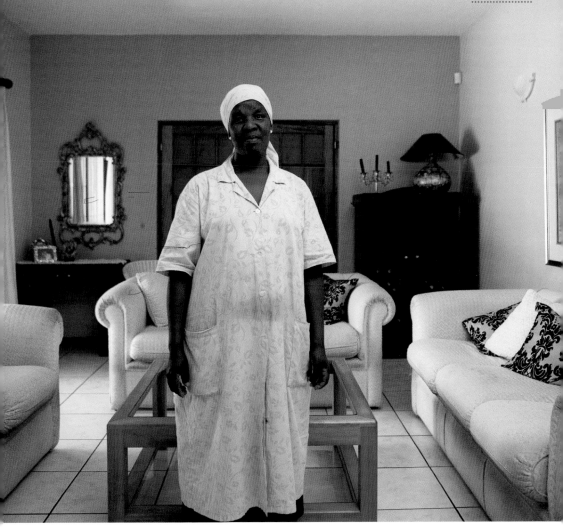

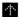

Title: *from* 'Boys and Girls', Gladys, East London, 2009

Photographer: Shaleen Temple

Shaleen describes her series of photographs as: 'a series of portraits of black South African maids and gardeners in their white employers' homes. Growing up in South Africa, before moving to the UK, means that this is an aspect of the South African lifestyle that I grew up with.

The project raises questions about how far the country has come since the end of apartheid and the relationship between the workers and their white employers.'

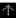

Title: Untitled, 1998–2002

Photographer: Gregory Crewdson

In this image, the 'magical and otherworldly' that Crewdson seeks, is achieved not just through the unusual combination of garden and kitchen, but the manner in which the set is lit and the relationship between the key aspects of the picture; not just *what* he is photographing but *how*.

Altered realities

The previous sections have explored the idea that every photograph is constructed. There are some kinds of photographs that are clearly constructed in order to convey a particular idea or concept in relation to an altered, decontextualized and re-presented reality. This might be achieved through photographing a constructed set or by manipulating an image, either in-camera or post-production, but the central theme behind the construction is the concept and the idea. Whether destined to be exhibited in a gallery or for use in advertising, the highly constructed photograph engages the viewer in a manner that challenges or distorts notions of truth and reality.

The American photographer Gregory Crewdson produces expensive and elaborately staged surreal scenes of American homes and neighbourhoods. The sets are constructed with painstaking attention to every detail, and are considered 'to hint and allude to the longings and malaise of suburban America'. Many filmic and artistic influences can be referenced within Crewdson's work.

In an interview at with Antonio Lopez at SITE Santa Fe in February 2001, Crewdson says: 'I think that, in a sense, there's something about photography in general that we could associate with memory, or the past, or childhood. I never literally made miniature trains, tableaus, or anything. But there is something very childlike in the process... I was very interested in museum dioramas, and I've always been interested in wanting to construct the world in photographs... whether or not it's in my studio or out on location. I think one of the things we can get from photography is this establishment of a world.'

'I have always been fascinated by the poetic condition of twilight. By its transformative quality. Its power of turning the ordinary into something magical and otherworldly. My wish is for the narrative in the pictures to work within that circumstance. It is that sense of in-between-ness that interests me.'

Gregory Crewdson, American photographer

Commercial use of altered realities

In terms of the establishment of a world, brands and companies use photographs to convey a sense of lifestyle when advertising and packaging their products. Many companies – from local independent businesses through to international conglomerates – use photography to varying degrees to state and enhance their company identity and encourage the consumer to buy into a lifestyle. This can be seen as the photograph creating or establishing a world which the consumer buys into.

From the photographer's perspective, the main thrust of the advertising brief is to work to create, and evoke in the viewer, this spirit of lifestyle. In some circumstances, the photographer is concerned with creating a piece of theatre, a stretching and distorting of the truth to allude to something beyond the product itself. In other circumstances, the theatre and distortion is in not so much the photographs but the context in which they are used and presented.

For example, musicians rely heavily on photography and other visual communication to convey their artistic identity in such a way that the creative ethos extends beyond the music itself and becomes a cultural experience through the visual language used. The album cover for Nirvana's *Nevermind* (showing a baby swimming and reaching out for a dollar bill) was photographed in California in 1991 by underwater photographer Kirk Weddle. Designed by Robbert Fisher at Geffen, the cover makes a striking image and is an ironic allusion to the band's counter-culture ethos.

This approach to the constructing of an altered reality often leads to this kind of playful, shocking and complex image that requires the photographer to engage with the world according to principles defined by the essence of an idea, in a way that is often removed from the ordinary existence of daily life.

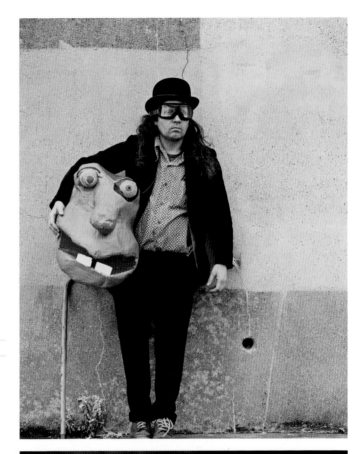

Title: Untitled

Photographer: Phil Glendinning

Constructed photographs do not always need big budgets. Phil Glendinning makes papier mâché heads and then photographs them in constructed scenes. Using himself as the model, Glendinning sets his camera on a tripod and uses a long cable release to fire the shutter when he is in place. During a studio demonstration, Glendinning became hot so removed the head between exposures. The student behind the camera took a photograph with the head in Glendinning's hands. Glendinning took this idea further to make new work with the head in the photograph but not worn, thus revealing himself; adding another dimension, referring to the portrayal of identity.

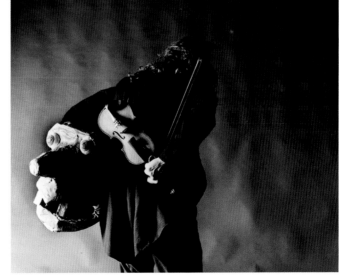

The photographic brief defines the context of the final output and, depending upon the nature of the brief, may also contain relevant information regarding conceptual approach. The photographic brief does not need to be complicated. For example, it might be as simple as a group of friends deciding to stop at a beauty spot to take a picture that will help them remember the day. The brief is clear; they know what they are making the photograph of, where and why.

To take the example further, one of the friends may have a film camera and one friend may have a digital camera, they decide to use the digital camera as it will be easier to distribute the image when they all get home. The group of friends have clearly outlined their brief and outcome and will relate to the resulting image accordingly.

We will now go on to look in more detail at the student brief, the self-directed brief and the professional brief.

Title: Nan

Photographer: Tim Mitchell

Here, foundation-level digital music student Tim Mitchell was responding to a two-word brief: 'Still time'. Mitchell stated that his personal learning objectives were to use his camera manually. He chose to photograph his grandmother in her environment during autumn, producing a set of images that link his grandmother's age and the time of year. Mitchell's inclusion of his own feet in one of the photographs makes a visual reference to the age of the photographer and a sense of the generation gap. These pictures were Mitchell's initial response to the brief.

'You must feel an affinity for what you are photographing. You must be part of it, and yet remain sufficiently detached to see it objectively. Like watching from the audience a play you already know by heart.'

George Rodger, British photojournalist

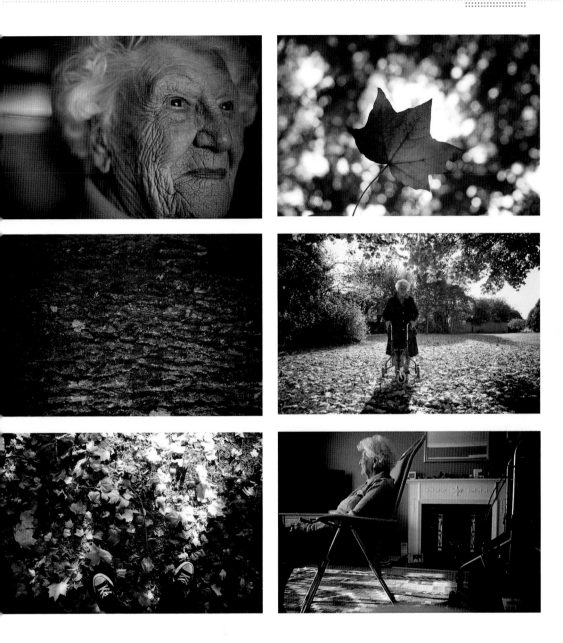

The student brief

Depending upon the nature of the course, it is usual for students to be set a project brief to work to for a defined period of time. If the project brief is quite specific – for example stating that the outcome is to produce work in a particular style, theme or using a specific technique – then the main thrust of the work to be undertaken is quite clear. However, many undergraduate courses will set quite loose briefs to encourage a more personal response and, in doing so, help students to identify their own key areas of interest, which will also act as a vehicle for developing a personal visual language. Either way, the brief will require students to initiate, develop and articulate ideas through translating them into photographic work.

It is therefore important to start researching ideas and making photographs as soon as possible, in order to take visual work to tutorials and group seminars and participate in the interactive feedback process. This method of learning and teaching encourages a genuine engagement with the relationship between concept and technique as well as the development of good working methods and problem-solving techniques.

Responding to a brief

· Read the brief carefully and list the key points you need to address.

· Clarify your own learning aims within the context of the brief.

· Break down your time into manageable parts. Make time for research, experimenting, processing, printing, digital manipulation and preparing the final presentation.

· Ensure you take images to share at tutorials and seminars.

· Practice verbalizing your idea; writing this down in order to organize your thoughts can help.

· Prepare questions you may wish to ask or ideas you may want to share.

· Keep a workbook and note down feedback given.

The group critique

· Make a note of how much time you will have to make your presentation.

· If relevant, practice your presentation so it fits into the time you are allocated.

· Note how you wish to present your work and any key points you wish to cover and questions you wish to ask.

· Contribute and give feedback to others as you will learn from this too.

· Give constructive feedback and objectively qualify statements.

Title: Dad

Photographer: Tim Mitchell

Mitchell further developed his ideas surrounding family roles and identity and moved into using black and white analogue photography. This image demonstrates a significant growth in his use of visual language as he is now exploring less obvious visual depictions and endeavouring to go beyond the immediate visual impact.

The self-directed brief

Having identified key areas of interest, in terms of conceptual approach and subject, one can set oneself a project and undertake it over a period of time alongside other work. These self-directed projects can often develop in intriguing and unexpected ways.

In a discussion of his work with Susan Butler in 1993, British artist and photographer Keith Arnatt explains: 'You start with an idea, however minimal, and then you get a result and you look at the result… I can't say exactly what, but something might have happened, you might see something in it, which departs or seems to depart radically from your original idea – it seems to give you a result which leads you somewhere else. This is not something I feel you can preconceive. The ability of the camera to transform that which is photographed, seems to me to be an eternal source of fascination.'

Arnatt's comments highlight the importance of giving oneself time to develop an idea through practice. Ideas can change and evolve in a whole host of unimagined ways, so allowing the time for this development is important. The picture-making process allows for the assimilation of ideas generated by the photographer's experience alongside their interaction with their subject.

Personal connection to subject

In an interview with Brian Sherwin, photographer Michelle Sank speaks about the relevance of her upbringing to her photographic work and emphasizes the importance she places upon the actual picture-making process: 'I am very connected to my subjects, whether it is on the street or in more constructed working environments. It is very much a two-way process and I have always said that the interaction I have is as meaningful as the photograph.'

Sank explains that the people she photographs have often experienced quite difficult lives and attempts through her portraits to: 'show the social, psychological and physical nuances of these people' through their sense of humanity. As she says: 'I believe growing up in the apartheid system, myself being part of a refugee community, drew me to photograph people living on the edge of society.'

Developing ideas

- Consider making one photograph each day at the same time, identify whether the time or the place has more importance.
- Collect photographs that you find inspiring in a workbook.
- Try picking a topic and then make your own photographs to form a collection.
- Set a target, such as one day a month to photograph your subject.
- Set aside time each week to research your ideas.

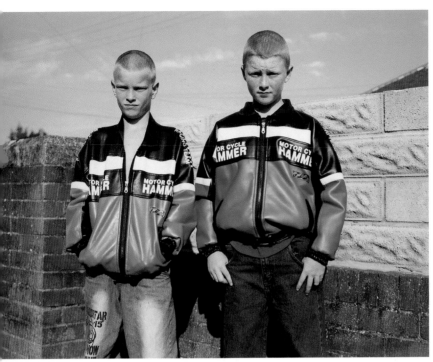

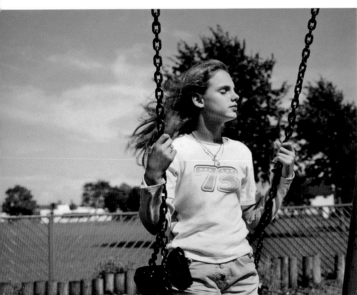

Title: *from* 'Young Carers'

Photographer: Michelle Sank

This project was undertaken during a residency supported by Ffotogallery, Cardiff, Wales. Sank photographed young carers; children under the age of 18 who were often the main carers for a sick parent or sibling. She explains: 'With these portraits, I wanted to empower these young people with a sense of their own identity and normality. I wanted to remove them from their home environment and place them within "light" and outside spaces. By getting them to dress in something they chose and to be themselves, I think for that moment in time they felt special, grounded and free.'

The professional brief

The professional brief is either 'pitched' to a potential client or funding body or responded to by the photographer when they are contacted by a potential client. Depending on the function of the photograph, photographers may be asked to submit an initial quote, offer ideas or make samples of work available to the client.

The context of the final outcome will inform not only conceptual and practical considerations, but also financial ones. It is, therefore, always worth taking time to gather as much information as possible at the first point of contact. It is important to find out how much time there is to put the quote together and agree when and how to send it. Responding and quoting on the spot can be fraught with hazards; avoiding this ensures there is enough time to research and reflect upon professional priorities and the ability to respond to the brief in an appropriate manner.

Balancing brief and subject

Responding to a brief in an appropriate manner is clearly demonstrated by British photographer Keith Morris, who photographed musicians over a period spanning four decades. Marc Bolan, Nick Drake, Janis Joplin, Ian Dury and Dr Feelgood were among the many musicians he worked with.

Morris was known for his passion and commitment, his ability to draw out the personality of each musician and, importantly, get the job done to a high standard with minimum disruption. He studied photography at Guildford Arts School and later gained an apprenticeship with David Bailey at the height of the 1960s. Morris's awareness of the social and cultural climate of the times can be seen in his documentary work and is echoed in both his approach to his musical subjects and in the environments in which he placed them.

'A great photograph is a full expression of what one feels about what is being photographed in the deepest sense and is a true expression of what one feels about life in its entirety.'

Ansel Adams, *Photographers on Photography:*
***A Critical Anthology* by Nathan Lyons (ed.)**

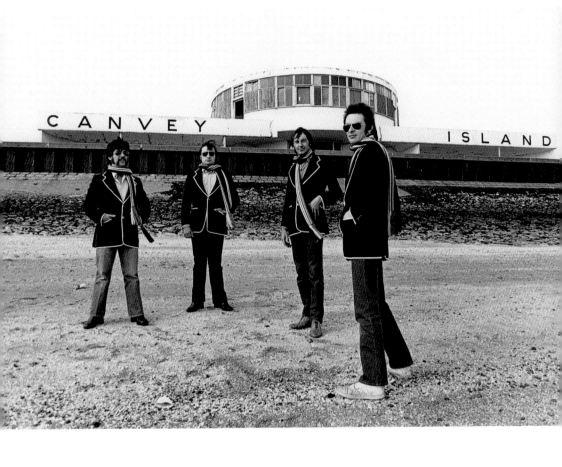

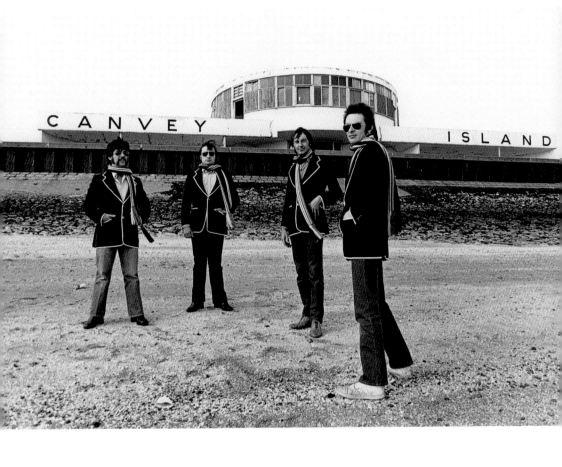

Title: Dr Feelgood, Canvey Island

Photographer: Keith Morris

Keith Morris was a prolific and committed photographer of musicians of diverse genres. Ex-Stiff Record's boss (and later Elvis Costello's manager) Jake Riviera explained: 'He had the knack of knowing exactly what a band was all about and capturing it quickly.'

Context will inform how the viewer places their interpretation of the photograph. The same photograph can be used in different contexts and take on different meanings in relation to that context. As photographers working to fulfil a brief, therefore, it is important to recognize the context in which the photographs will be used and seen. Context can be defined by: the function of the photograph; the placing of the photograph; the relationship between the photograph and other photographs in the same series or body of work; use of text and more external factors, such as topicality; geographical placing of the photograph; the cultural understandings and experiences the audience bring to the photograph.

Contextual distortion

A good example of how context can affect meaning occurred when artist Joy Garnett used a portion of a photograph by Susan Meiselas as the basis for her painting *Molotov Man*. Meiselas' original photograph showed a member of the Sandinista National Liberation Front in Nicaragua throwing a bomb at one of the last remaining Somoza national guard garrisons. The photograph was taken on 16 July 1979, the day before the dictator Anastasio Somoza Debayle fled Nicaragua. Meiselas presented the photograph within a larger body of work that shows many aspects of the situation that are politically, socially, culturally and now historically relevant to the subject's actions.

In Garnett's painting, the subject is seen as a random rioter expressing anger. The re-contextualizing of Meiselas' photograph in Garnett's painting could be seen to be not just disrespectful of the significance of the subject's actions and intents but also disregarding what was, for those involved, a serious and long drawn out battle for what they believed was justice.

In *Harpers Magazine* in February 2007, both Garnett and Meiselas talk about the incident. Meiselas believes: 'There is no denying in this digital age that images are increasingly dislocated and far more easily decontextualized. Technology allows us to do many things, but that does not mean we must do them. Indeed, it seems to me that if history is working against context, then we must, as artists, work all the harder to reclaim that context. We owe this debt of specificity not just to one another but to our subjects, with whom we have an implicit contract.'

Meiselas is focused on protecting her subject's integrity and motivations and what could be described as a level of historical accuracy and broader understanding. As this incident demonstrates, it is vital for photographers to recognize both the practical and ethical implications of context and develop their own sense of ethical boundaries and a professional code of practice.

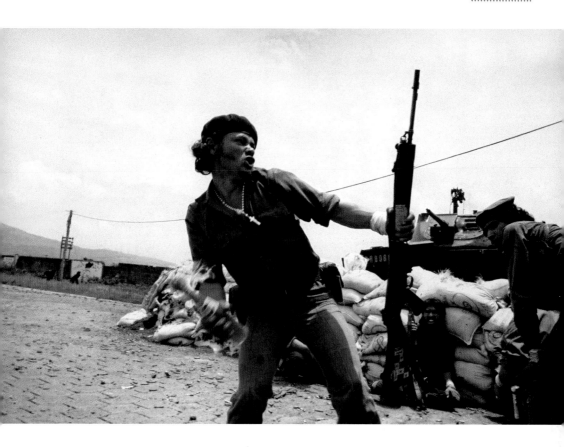

**Title: Sandinistas at the Walls of the Esteli National Guard
Headquarters, 1979**

Photographer: Susan Meiselas

Susan Meiselas explains: 'It is important to me – in fact, it is central to my work – that I do what I can to respect the individuality of the people I photograph, all of whom exist in specific times and places. So here is some context: I took the picture above in Nicaragua, which had been ruled by the Somoza family since before World War II. The FSLN, popularly known as the Sandinistas, had opposed that regime since the early 1960s…

'I made the image in question on July 16, 1979, the eve of the day that Somoza would flee Nicaragua forever. What is happening is anything but a "riot". In fact, the man is throwing his bomb at a Somoza national guard garrison, one of the last such garrisons remaining in Somoza's hands. It was an important moment in the history of Nicaragua – the Sandinistas would soon take power and hold that power.'

Required output and destination

When responding to a professional brief, it is vital to establish the required output format. Is the final image needed as a digital file, a colour transparency, a print or another format type? When working to a self-directed brief it may be that part of the process is to experiment with a variety of output formats in relation to developing the conceptual approach.

Having established the format required, it is important to fully understand exactly where and how the image will be used. For example, some situations will require an approach that conveys a sense of time and place; images that are evocative and create atmosphere. Other photographs will require that the viewer can see as much detail of the subject as possible in an almost clinical and exact manner. The use of text – which we will address in Chapter 6 – will greatly influence the reading of an image too.

It is also worth bearing in mind how photographs can relate to one another within a body of work. A photographer might create a set of images to convey an overall sense of the work with individual photographs working to convey quite specific aspects of the overall narrative. Order, size, shape and placement on the page can all work together to inform how the photographs are seen and read. The presentation of the photographs functions as part of the concept. It is important to ask whether the presentation echoes, informs or works as part of the concept. Does the method of presentation work in accord with the conceptual approach?

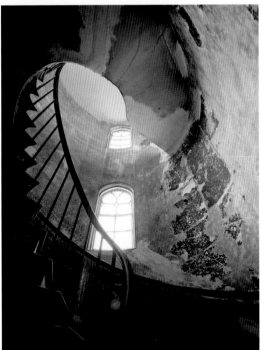

Title: Pavilion Unseen

Photographer: Michael C. Hughes

Photographing at night, using only floodlights from outside the Royal Pavilion (an iconic building in the vibrant UK city of Brighton), Hughes developed an idea to photograph 'through the layers' of famous buildings. Hughes incorporated the use of external floodlight to conceptually allude to the sense of the 'theatrical stage', unlit, to infer the presence of past inhabitants as actors waiting in the wings. The accompanying booklet to the exhibition reflects the journey through time and space.

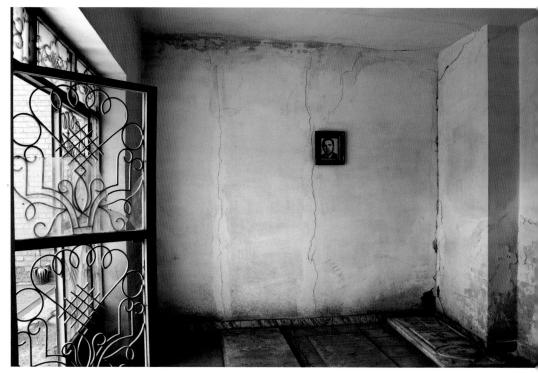

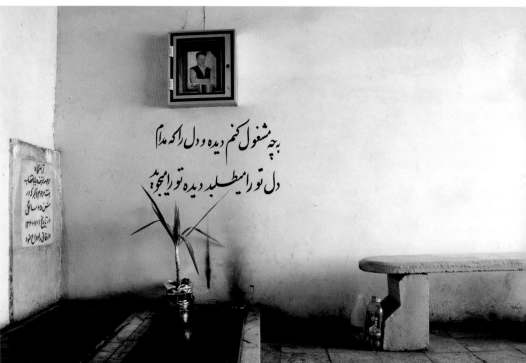

'Photographers should actively look for ideas, attitudes, images, influences from the very best photographers of all ages. You cannot learn in a vacuum. The whole history of photography is a free and open treasure trove of inspiration. It would be masochistic to deny its riches and usefulness.'

David Hurn and Bill Jay, *On Being a Photographer*

Title: Family Burial Chambers

Photographer: Mehdi Vosoughnia

Photographs of the dead are displayed in the burial chambers in an old graveyard of Qazvin, Iran. Some of the photographs are more than 50 years old. Vosoughnia photographed the burial chambers during 2005 and 2006 and describes the experience: 'Once again, they are in front of a photographer. Now nobody dies for them and nobody falls in love with them. Only their memory comes and goes every now and then. In their time, they would step into a photography atelier to eternalize themselves and today I, the photographer, have stepped into their sanctum to record their photos.'

Cultural and social climate

As well as the more immediate context of the required output and destination of the photograph, it is also important to bear in mind the cultural and social context that the final image will be viewed in. For example, will the photograph be making any direct references to topical events or will it take on a new meaning or further dimensions because of local beliefs, current events or viewers' experiences?

In the same way as it is important to appreciate local customs when visiting new places, it is also important to bear in mind audience experience and expectation when creating and placing images topically and geographically.

In a BBC Radio 3 interview with John Tulsa, Magnum photographer Eve Arnold talked about explaining what is going on in her photographs through captions; specifically where she did not speak the language and had little understanding of what she was capturing: 'After I had worked I got an interpreter to tell me what was going on… If I couldn't gauge what was going on exactly, then I wondered whether my viewers would be any brighter and understand better… Now the vogue is to put the caption in the back of the book and you keep flipping back and forth, caption, picture, picture, caption, and I think that's arrogant.'

This is Arnold's opinion and, to a certain extent, her rationale behind working. All photographers have personal codes of practice and ethics as well as our own unique creative vision, which we will now go on to look at.

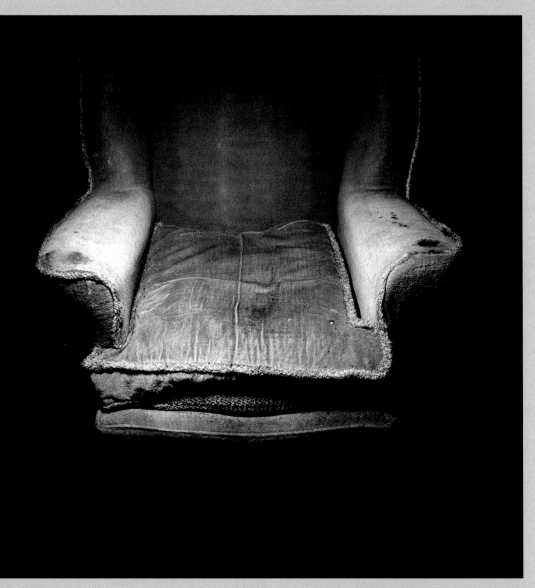

Title: *from* **'The Regency Project'**

Photographer: Richard Rowland

'Due to my previous working life as a drugs counsellor and homeless support worker, it was an environment that I could function in with relative ease, which proved to be a great benefit when working with these often marginalized people.

'I was able to engage in a project that reflected some of the social concerns I have, while applying a documentary approach to explore some of these themes. My approach was to photograph the residents, the spaces and the objects left behind.'

Case study

For almost a quarter of a century The Regency House has offered privately run accommodation for homeless men in the south of England. By the early 2000s it had developed a reputation as a dangerous and dirty place. Largely forgotten, the building had drifted into squalor and was increasingly neglected, along with the 55 men inhabiting it. The men came to the house for various reasons, often with alcohol, drugs, mental health problems and relationship breakdowns playing their part. There had been no help or assistance available to them for years, and the atmosphere in the house was one of desperation and resignation. The once grand building, complete with ornate cornices and impressive arched windows, had become a diminished territory.

Change came in the shape of the Brighton Housing Trust's plans for a radical refurbishment. The building, one that seemed to have opted out of the street in which it resided, was to undergo a three-year refurbishment in a project designed not only to deal with an overhaul of the building, but also to create a network of support and facilities for the men who would use its services.

At this time, Richard Rowland was working for the housing association that had recently purchased the building. When he heard about the state of the building and the plans to redevelop at, he thought it seemed like a great project to get involved with. He arranged a meeting with the director and outlined his project proposal: to document the restoration process and the lives of those inhabiting the building.

Revealing a social history

Rowland explains his motivations for becoming involved in the project: 'In particular, my interest lay in the historical and cultural aspects of the building. As it was stripped back, I was interested in recording the layers of the property that had been hidden for many decades. Layers that didn't simply expose the structural elements, but also revealed something of the social history present – the lives gone before and the cultural references left as markers on the very fabric of the building – histories embedded in, for example, an old chair, a tobacco stained repro-painting or a tired, frayed carpet.

'As the project developed, I found myself increasingly wanting to photograph the residents. Although these portraits form a small part of the body of work as a whole, they are key elements underlying the importance and relevance of this particular restoration project. Not merely an undertaking to revive an old Regency building, but one that directly impacts on the lives of so many people who desperately need such a "home".'

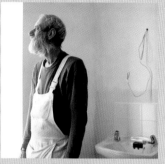

Rowland drew upon his professional experience as a drugs counsellor and homeless support worker to interact in an appropriate manner while photographing on location and when engaging with the ethical issues surrounding the project. Rowland's vision of the potential of this project comes from him combining his cultural and social awareness with his personal approach to photographic language; thereby employing his own personal and professional strengths.

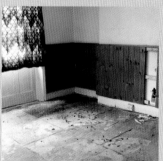

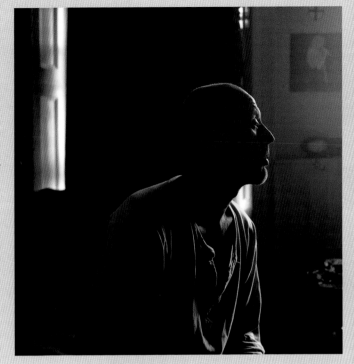

Title: *from* **'The Regency Project'**

Photographer: Richard Rowland

Using a Kodak Portra VC 400, a
Hasselblad 6x6 format and mainly
natural lighting with the occasional
use of direct flash, Rowland made
approximately 55 visits to photograph
the location and its inhabitants.

Exercises: Consider the photograph

→ Make a collection in your workbook of found photographs that represent various usages of photographs. For example, one advertising photograph, one editorial photograph and so forth.

→ Make notes regarding the key aspects of each photograph.

→ Assemble some photographs by photographers whose work you are instinctively drawn to; put the photographs somewhere you can see them regularly and try to identify the inherent qualities that you are attracted to.

→ Compile a set of photographs from your personal collection or 'family album'. Contemplate the photographs and think about their key components in relation to your response or relationship with them.

→ Consider how topical and geographical issues can influence the creation and placing of your images, think of several possible scenarios and how you would incorporate them into your work if necessary.

→ Try presenting one photograph in several different ways and see how it could be used in varying contexts.

→ Visit exhibitions and consider the presentation of photographs; did size, shape and sequencing inform your response?

Summary

⟿ We have briefly explored notions of truth and reality in relation to the photograph.

⟿ We have acknowledged that in many ways and on many levels, photographs are constructed creations.

⟿ The function of the photograph will inform the photographic approach.

⟿ The context in which a photograph is viewed will heavily influence its interpretation.

⟿ Photographic terminology itself is also offered for debate, as the implied connotations often refer to notions of truth and authenticity.

⟿ By looking at the approach and work of specific photographers we can see that while it is important to engage with and be aware of the implications of ongoing theoretical debate, each photographer will bring their own unique approach to the professional practice.

⟿ We will explore this 'unique approach' of the photographer in the next chapter as we go on to discuss using photography to explore your interests and communicate your ideas.

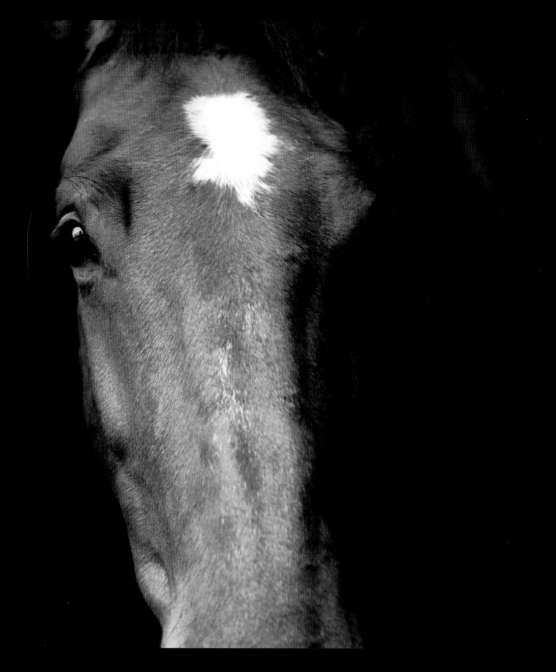

Subject

Title: *from* 'Horse Portraits'

Photographer: Maria Short

When the audience see the subject looking directly into the lens, a relationship is initiated, based on the gaze between subject and audience.

Choice of subject and how it is photographed is a crucial aspect of visual language. The subject matter is what the audience will 'see' and therefore will either inform or challenge a range of interpretations that are implicit within the subject itself, the audience's understanding of it and existing representations of the subject. Recognizing this three-way relationship between the subject, the photograph and the audience will inform how the photograph is made and presented.

2

In his essay 'The Decisive Moment', French Magnum photographer Henri Cartier-Bresson states: 'I believe that, through the act of living, the discovery of oneself is made concurrently with the discovery of the world around us, which can mould us, but which can also be affected by us. A balance must be established between these two worlds – the one inside us and the one outside us. As the result of a constant reciprocal process, both these worlds come to form a single one. And it is this world that we must communicate.'

To be a photographer, you need to be passionate about communicating 'something', as this will inform every choice you make in relation to your work. To be a photographer, you also need to be interested in the world around you; you need to be interested in things beyond photography. The substance of the work is in your commitment to your subject, as this will show in your photographs, this commitment will make your photographs breathe; this is how to 'personalize' your work. If you are clear about why you are photographing your subject then you can choose *how* to photograph your subject, and in turn this should help your audience interpret the photograph.

Title: *from* 'Constructed Childhoods'

Photographer: Charley Murrell

Charley Murrell explains how her project 'Constructed Childhoods' explores the impact of images that surround children's everyday lives: 'Images found in advertising, magazines, television, the internet and other media, toys and some food products have a significant impact on how children view themselves. Children look to see themselves reflected in this multitude of images and in part they construct their own sense of self from these images. My project explores these constructed childhoods using different media surfaces to represent children's "ideal" selves in relation to their reality.'

Communicating intention – key questions

· Do you actually need to photograph the subject itself; can you communicate your intention by referring to, implying or photographing around it?

· If photographing the subject itself, ask yourself how important is location, time of day, quality of light, equipment and materials in relation to the concept?

· What do you need, or want, to show and share with your audience and how are you going to do that?

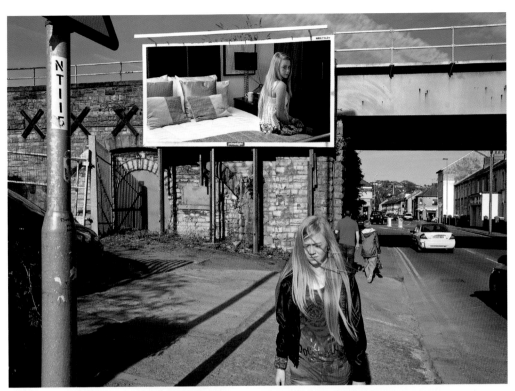

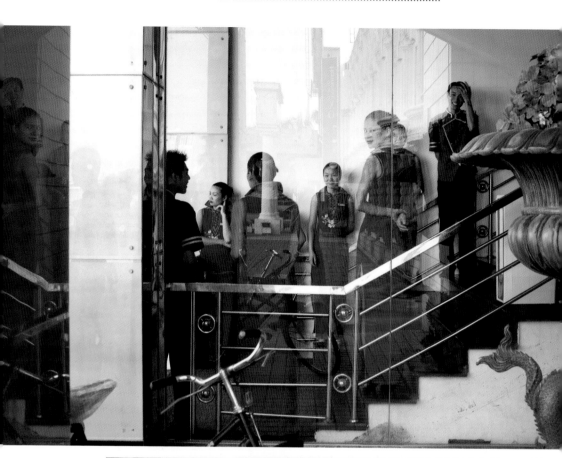

Concept is directly related to *why* you are photographing your subject; your concept links your subject to context, in that it is *why* you are photographing and in *what* manner. To a certain extent, concept is one's reason or intention.

One of the most important questions to consider is 'why a photograph?' Why not present the subject itself, or a painting, a sculpture, words or another form of representation? In the most basic sense – for example a photograph of a property for sale – the answer may be 'it is physically impossible to transport the thing itself'.

At other times, it may not be as simple as that, in which case it is worth carefully considering the role photography plays in influencing how the audience perceives the subject, simply because it has been photographed. By choosing to make a photograph, one is already engaging with a range of references and implications that the audience will bring to their reading.

This is why it is important to understand the manner in which context informs interpretation, not just in relation to the subject and conceptual approach but also to photography too. Having thought through why you are *photographing* your subject, rather than writing about it or painting it, the next stage is to consider your intention or rationale. What is your intention; what do you want to say?

Title: *from* 'China Between'. Restaurant Staff Gather for a Pep Talk and What Time is it There? (Xiamen 2007).

Photographer: Polly Braden

'China Between' is a photographic essay on the modern city culture of contemporary China. David Campany, writer and curator, describes Polly Braden's work: 'What she was trying to discover, without fully knowing it for a long while, was a form of observing, shooting and editing that might express the complicated relation between everyday life in China's burgeoning cities and the great transformations that have been taking place there.'

An individual viewpoint

Your own beliefs, sense of integrity, intuition, personal qualities and technical skills will all influence the rationale and concept for your work – what you photograph, how and why. These individual characteristics are essential components of the image-making process. American Magnum photographer Eve Arnold is a useful example of how personal viewpoints, personality and even subjectivity can lead to insightful photography. In an interview with Mark Irvine, Arnold responds to a question on the political agenda of the photographer by explaining her intention in photographing her chosen subjects:

'There have been times when I've set out to show people to be what they are – like Joe McCarthy, who held America for ransom for many years and ruined a lot of lives.' Arnold goes on to stress the inevitability of being influenced by wider society: 'We're all political agents. How do you divorce yourself from the system you live in? You have feelings – it's not just wind whistling between the ears.'

Arnold is acknowledging that, particularly in the case of controversial US politician Joseph McCarthy, her own attitude to the subject influenced how she photographed him. She goes on to explain that photographers can develop a more meaningful interpretation of their subject through physical proximity and by developing a level of personal understanding and involvement. When asked about the long lens photography of the paparazzi she says simply: 'What they do has nothing to do with intuition, I don't regard that as photography because all you're doing is making a record shot. It is very different when you're working with someone.'

Understanding the subject

Fellow Magnum photographer, Elliott Erwitt explains how Eve Arnold translated these beliefs, and her own character, into the way she worked and the resulting photographs: 'The thing about Eve is that she has been able to get into situations that other people do not get. She's the most non-aggressive, pleasant, approachable, non-threatening person that you can imagine. And these are all wonderful qualities in getting pictures that others don't get.'

Eve Arnold used her social skills to gain a fuller understanding of her chosen subjects and was able to use this insight to develop a concept for each. Having a clear understanding of concept, the rationale for a piece of work, will inform many decisions you will make as a photographer; prior, during and after the actual picture-making event. The conceptual approach is the essence of the process and the photograph. From informing subtle choices concerning subject, materials, composition and final presentation, the relationship between concept and subject underpins all that the photographer does.

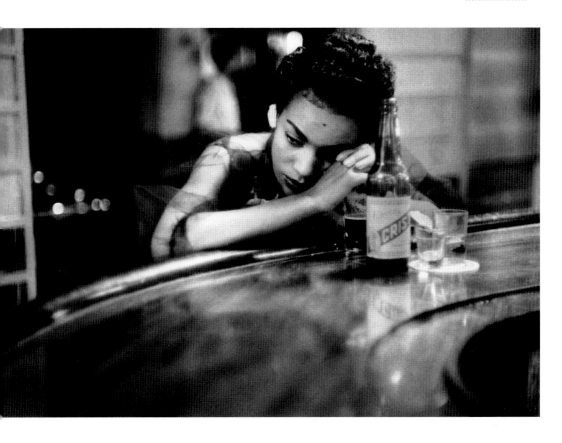

Title: Cuba. Havana. Bar Girl in a Brothel in the Red Light District. 1954.

Photographer: Eve Arnold

On the day after her 98th birthday, at the annual awards ceremony in Cannes on 22 April 2010, Eve Arnold received the Lifetime Achievement Award at the Sony World Photography Awards. Baroness Helena Kennedy QC said: 'Eve always created real trust with the people she photographed and I think that meant she captured things about those people that were often missed by others.'

Having considered subject and concept, the next stage is to select appropriate equipment and materials to realize the project. The equipment and materials you use will, of course, inform the look of the resulting image. However, it is important to remember that the viewer's response will depend not only on the way in which you've used the materials, but also on the viewer's pre-existing expectations about them. Of course, one can challenge these expectations, or subvert them, but it is important to recognize the preconceptions in order to address them appropriately.

Technical execution is vital in supporting the conceptual approach and the viewer's reading of an image. For example, look at the work of a range of different photographers and consider how their choice of format, film quality and presentation informs your reading of the image. Similarly, think about the rendering of tonal quality and sharpness of detail in relation to your reading of the image. Would your reading of the image be altered if the image were more or less grainy, or if it was colour as opposed to black and white?

The presence of the camera

Be mindful of the way in which the following camera formats might affect your relationship with the subject during the picture-making process.

· Holding a 35mm or rangefinder up to your eye.

· Holding a medium format with a prism to your eye.

· Holding a medium format at waist level, looking down to focus and then back up to the subject with direct eye contact.

· Using a tripod and perhaps cable release.

· Using large format, taking time to set up the picture.

· Stopping to reload film.

· Stopping to check digital images.

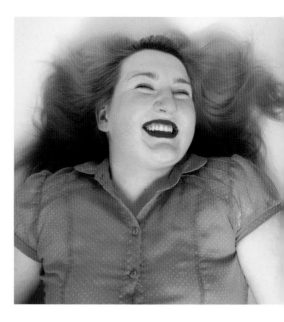

Title: *from 'Pickled'*

Photographer: Olena Slyesarenko

Olena Slyesarenko photographed her subjects under water. Keen on ambiguity, Slyesarenko aimed for the water to be as unnoticeable as possible to the viewer. She used the water to reduce the amount of control her subjects had over the resulting images.

Slyesarenko observed how, despite enduring a range of pain and panic, her subjects still strived to maintain composure and present themselves in as controlled a manner as was possible as they were mindful that their 'image' would be recorded as a permanent photograph.

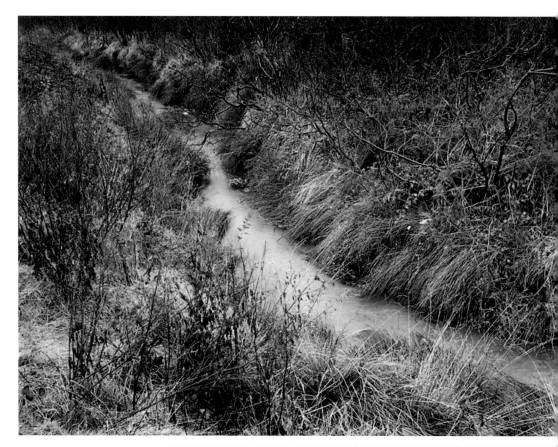

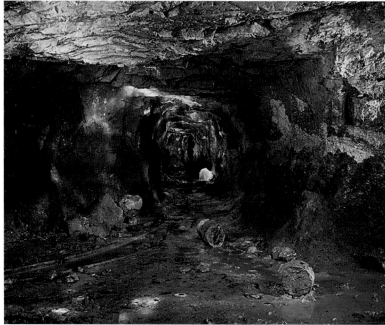

Title: *from* **'The Red River'**

Photographer: Jem Southam

Southam photographed 'The Red River' series from 1982 to 1987. The project follows a stream stained red by mining, from its source in West Cornwall, UK, to the sea. Travelling through a landscape influenced by the copper and tin mining ore, horticulture and tourism, the series conveys the history and legacy of cultures that have shaped the landscape. Southam frequently revisited sites and his knowledge of and connection with his subject, combined with sympathetic use of photographic technique, communicates articulately and poetically.

Camera format – key questions

Choosing the appropriate equipment, and developing a personal style of using it, are both intrinsic aspects of any photographer's unique approach. This approach impacts upon the resulting images in ways that contribute to their visual language. Some key questions to ask yourself when choosing equipment are:

· Which format camera will best suit your conceptual intention: vintage camera, 35mm, medium or large format?

· What kind of image quality will best reflect and interpret your intention. For example, is fine, very sharp detail important?

· What shape do the images need to be: square or rectangle?

· Will any converging lines need to be corrected (i.e. for architectural photography)?

· Do you need to be quick and mobile? If so, a heavy, large-format camera may be inappropriate.

· How large are the final prints intended to be or will they be presented on-screen?

· Are you referring to an established style or genre of photography?

· Will film or digital be most appropriate for your required final output?

· What is the overall flavour or look that you'd like to achieve in the final images and how and where will they be seen?

· Do you need to continually communicate with your subject or with others in the environment? If so, you will need to develop a manner of working with your equipment that facilitates this.

'My overall artistic intentions are to make work that
explores how our history, our memory and our systems
of knowledge combine to influence our responses
to the places we inhabit, visit, create and dream of.
But that's me putting a gloss on it. I am compulsive
and I work because it is what I want to do. The
photographs are the result of a need to make work in
the most challenging and enjoyable way possible.'

Jem Southam, British photographer

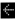

Title: *from* 'The Red River'

Photographer: Jem Southam

Jem Southam explains some of the technical decisions that have influenced his work: 'I bought a MPP 5"x4" Field Camera in 1975 and started working in colour. But I didn't like the results. They were too saturated and not what I was trying to do. So I stopped and spent the next six years working with the same camera in black and white. I became heavily influenced by the Bechers and pursued architectural landscape work.' Southam explains that it was Paul Graham showing him some of William Eggleston's work that caused him to realize that materials did exist which would allow him to work with colour in a way he wanted to and so he switched back to colour and has not taken a black-and-white photograph since.

Technical considerations

Your choice of film type, speed and other technical considerations in relation to the intention and final output are important factors in the image-making process. Before making these decisions, it is worth asking yourself whether you wish to lean toward particular colours and tones, how much grain or noise you want and if you plan to do any correction or manipulation at post-production stage. How and where the final output will be viewed is especially important when considering image quality.

Technical points to consider that will support your concept:

· Colour or black and white?

· Digital or film?

· Print or transparency?

· Film speed and grain?

· Available light or flash?

· 35mm, medium or large format?

· Cameraless photography?

· Print or screen based?

· Paper type?

· Printing process?

Photographers frequently need to deal with external factors, such as delayed transport, weather conditions and people. Any one of these elements can completely change the nature of a shoot. This is when thinking on one's feet is required; using creative ability and interpersonal skills. The key is to hold in mind your conceptual intention and look for new ways in which it can be visualized.

It is also worth bearing in mind that the subject or people within the environment will have their own expectations of how both the photographer and subject will and 'should' behave, for example: either posing for the camera in a certain way or expecting lots of photographs to be made very quickly. This can sometimes be a bit off-putting, but it is important to find a way of working as harmoniously as possible and discussing expectations during the preparation stage can help with this.

Finding a common passion

One example of external factors influencing, or in this case creating, a project is Seba Kurtis' 'Salam' (see overleaf). Kurtis describes the making of 'Salam' as follows: 'I went to photograph in North Africa, where human traffickers create new routes to smuggle immigrants to Italy, Greece and so on. After two days, my fixer gave me a knife for protection and then disappeared. I don't speak Arabic, my 5x4 and I weren't welcome in many places and I felt a lot of friction, even with the everyday people in the streets – some even physically tried to stop me taking photographs.'

During his journey, Kurtis was fascinated to come across photo studios in every village. Here in these studios he was greeted warmly and enjoyed passionate and enthusiastic exchanges about photography. He then took to visiting the studio in each village, while he was waiting for access or a contact to appear. He describes the experience: 'Solace was found in local photographic studios where both my face and camera were warmly received with respect, our common passion uniting us – the language of photography. There was something beautiful yet naive about their struggle to resist globalization, their willingness to sell ice creams and hair products within their practice just to keep their dreams alive. Unexpectedly, this project came alive in those places where time seems to have stood still but hearts were open.'

The influence of personal background

It is worth bearing in mind that Kurtis was born in Argentina in 1974 and grew up in Buenos Aires under a dictatorship. He studied journalism and was a political activist. In 2001, Argentina fell into economic and political crisis. Kurtis left for Europe and remained in Spain as an illegal immigrant for more than five years. So it could be fair to make links between his life experiences and the manner in which he pursues and develops his photographic work. In his most recent work 'The Promised Land', commissioned as winner of the Vauxhall Photography prize, he has produced a series of portraits capturing the essence of British people today; whether they are born and bred in the UK, second-generation residents or illegal immigrants.

Missing information

Consider the three-dimensional experience when photographing your subject, list points that work to create the atmosphere you want to capture that will not be visible in the picture, consider how these impact the 'silence' of the photograph and whether there are visual ways in which they can be included or referred to. For example:

- Background noise: music, street sounds, birdsong, tractors, horse hooves.
- Smells: coffee, grass, sea, flowers, unpleasant stench.
- Temperature and climate: heat, humidity, wind, cold.
- People's accents and dialects.

'There is one thing the photograph must contain; the humanity of the moment. This kind of photography is realism. But realism is not enough – there has to be vision and the two together can make a good photograph. It is difficult to describe this thin line where matter ends and mind begins.'

Robert Frank, *World History of Photography* by Naomi Rosenblum

photo by
Ahmed Abo Elazm

Title: *from* 'Salam'

Photographer: Seba Kurtis

Seba Kurtis went to North Africa and, while experiencing hostility and difficulties in accessing his intended subject matter, he wandered into a photographic studio out of curiosity. Here he found a warm welcome and the shared passion for photography enabled a positive exchange. So, as he continued his travels, he visited the photo studios in the towns and villages along the way.

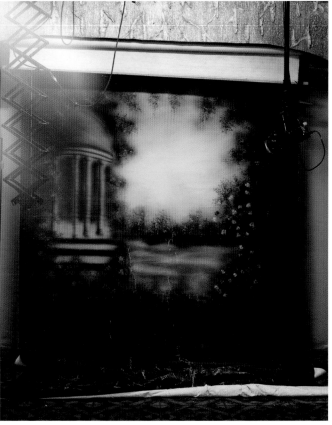

Location and time

The nature of the brief will dictate whether photographs are to be made during a 'once only' opportunity or over an extended period of time. Lighting conditions, and the appropriate use of them, will have been explored as part of the research and preparation for the project. In some cases, an image might depend upon weather conditions and require specific light at a certain time of day. This may require a level of flexibility and patience, waiting for clouds to move into or out of the frame or dawn/dusk to approach.

In the article 'A View of a Private World' Alex Novak shares the experience of Sonja Bullaty when she was assistant to Czech photographer Josef Sudek: 'His sense of light became crucial, often planning for a year or more to capture the exact lighting situation… We set up the tripod and camera and then sat down on the floor and talked. Suddenly Sudek was up like lightening. A ray of sun had entered the darkness and both of us were waving cloths to raise mountains of dust "to see the light", as Sudek said. Obviously he had known that the sun would reach here perhaps two or three times a year, and he was waiting for it.'

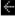

Title: Summer's Bounty

Photographer: Ray Fowler

Ray Fowler knows this area of countryside well and has experienced the landscape through the changing of the seasons over several years. Through his knowledge of the area, he was able to anticipate the seasonal conditions and ensure he used the appropriate equipment and materials at the right time of day to record this scene. Using a Hasselblad Xpan, with a 45mm lens and Velvia film, Fowler set out to maximize the sweep of the landscape, sky and colours, being aware that condensing the landscape through a camera lens can be a disappointing experience in comparison to the joy of experiencing the landscape in three-dimensions; hence his choice of a panoramic format. His experience of the location, combined with his vast knowledge of equipment, equates to researching his subject and technique in order to produce the image he had in mind.

Prepare and be flexible

This clearly illustrates the value of knowing one's subject matter and being prepared to catch the right lighting conditions. Conversely, as important as it is to be prepared to be in the right place at the right time, it is also important to be flexible with how one's intention can be manifested visually. Being too prescriptive in approach, spending hours looking for an exact image, can mean that you overlook hundreds of other possible images. It is therefore important to cultivate a sense of openness towards the subject, looking for possible compositions and dynamics.

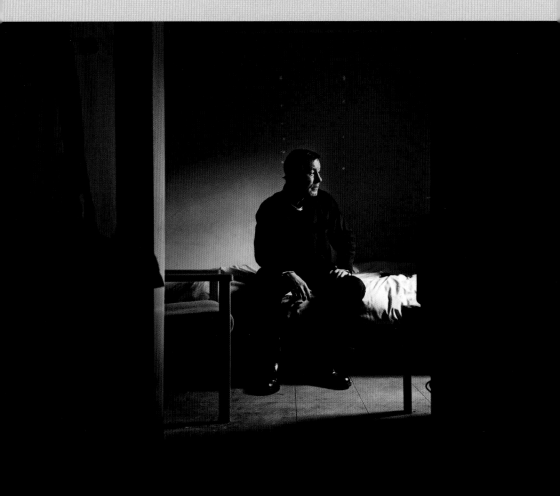

Title: *from* **'Homeless Ex-Service'**

Photographer: Stuart Griffiths

Using a Leica camera and Kodak film,
Griffiths documented the residents
of the hostel for ex-servicemen.

Case study

In 1988, at the age of 16, Stuart Griffiths joined the Parachute Regiment. It was a move to avoid what Griffiths describes as 'the mundane life' of his home town of Warrington, UK. After five years of service, Griffiths recognized that what he enjoyed most about his service career was his role as a unit photographer. Griffiths therefore decided to leave the Parachute Regiment and pursue a career in photography.

In 1997, four years after leaving the army, Griffiths obtained a degree in editorial photography. He went on to pursue self-directed projects exploring military conflicts in Albania, private military armies in Baghdad and the civil war in Congo. As Griffiths recounts, these projects could be fraught with danger: 'The trip to Kinshasa was probably the one place I was totally ill-equipped for; emotionally and mentally. It was here I found myself being taken through jeering crowds, mock executions, intimidation and abuse; I ended up in a Congolese jail.' However, the deep-rooted conviction that his life, his voice and his opinions had relevance and value kept him working. Specifically, Griffiths wanted to convey an aspect of the reality of army life. He wanted to create a sense of empathy with, and understanding of, the challenges facing ex-soldiers.

Funding these projects while trying to support himself was a costly exercise, and by the year 2000, Griffiths was homeless and working as a paparazzi photographer in London. While trying to find somewhere to stay, he became aware of a hostel for ex-servicemen. Here Griffiths met a group of men whose challenges he could identify with. Griffiths began photographing homeless ex-servicemen and this work was first published at national level in UK newspaper *The Guardian* in May 2005.

Influences

Griffiths emphasizes the importance of having a connection with, or passion for, one's subject as he talks about his influences: 'I got into looking at photography in my early teens. Nick Knight's *Skinhead* (1982) was a book I bought early on, because I was a skinhead myself and wanted to know more about this way of life.

'Later on, when I was a student, Paul Graham's *Troubled Land* (1987) was an influence; he photographed some of the areas I patrolled as a soldier and what was interesting for me was that his photographs were very subtle, with only suggestions in the photos of the ongoing conflict in Ulster.

'I was encouraged by Philip Jones Griffiths, notably his book *Vietnam Inc.* (1971). When I first saw his work I was deeply moved by his commitment to his subject and how the book was from the Vietnamese perspective. … I met Philip Jones Griffiths a year before he died and he was a kind of mentor to me, urging me to carry on with my veterans' work. We also shared a similar contempt for the controlling 'embedded' photographer position that is currently the norm in modern war reporting. I was also inspired by the commitment of Chris Steele-Perkins to bodies of work surrounding socially excluded areas, in 'The Ted's' (1979).

Then I started getting into the work of American photographers; William Eggleston, Stephen Shore, Lee Friedlander, Diane Arbus, Nan Goldin. I was deeply inspired by these artists, because they photographed what was around them, however mundane, it was the documentation of their own personal journeys that had a huge impact on the way I look at what is around me. It is this subjective autobiographical viewpoint that I look for in my own practice as a photographer.'

Griffiths' story and his photographic work are documented in the film *Isolation* (2009).

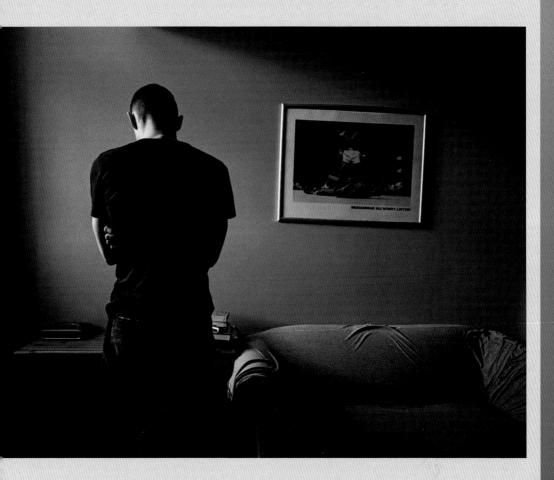

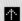

Title: *from* 'Homeless Ex-Service'

Photographer: Stuart Griffiths

Griffiths wants to create a sense of
empathy with and an understanding
of the challenges facing ex-soldiers.

Exercises: Focus on subject

⟶ Make a list of activities you enjoy, the environments you prefer and note whether you enjoy them with others or alone. This will inform your 'process' list. It may indicate your aptitude for certain working environments and conditions. Next, make a list of 'things' people associate you with, such as cats, dogs, music, theatre or clothes. This will inform your 'subject' list. Finally, make a list of what interests you. For example, when you watch television or films, listen to or read the news, which stories appeal to you most? This can inform both your 'process' and 'subject' list.

From these lists, identify which items can be translated into the process of photography and which items can be translated into subject matter.

Now from your list of subject matter, ask yourself, is it visual? Choose one point from your 'subject' list and one point from your 'process' list. See if you can combine the two points and photograph your chosen subject using your chosen process. This may help clarify your strengths and may give you an insight into your true interests and motivation.

⟶ Look at the work of other photographers. What appeals to you; visually, technically and conceptually? Pick a photographer or an approach and set yourself a brief to respond to using a similar technique or concept. A simple brief that has clear boundaries and time scale can be helpful. Photographing your ten favourite possessions, a regular route or in one place for a set time period can be helpful ways of identifying the kind of work you find engaging.

Summary

→ We have explored the source of ideas and the rationale or concept that drives photographers' work.

→ We have emphasized the importance of the photographer being passionate about and having respect for their subject, while also bringing their personal qualities and skills to the process.

→ The picture-making process is not divorced from the photographer's life-experience and personal ideologies and is, in some cases, the creative manifestation of them.

→ In recognizing these significant aspects, we can acknowledge that the photographer's professional development runs concurrently with, and is a two-way process between, creativity and the development of individual beliefs and ethics.

→ We will now go on to look at the impact of the photographer's conceptual approach, personal ideologies and codes of ethics upon the interpretation of their work by the audience.

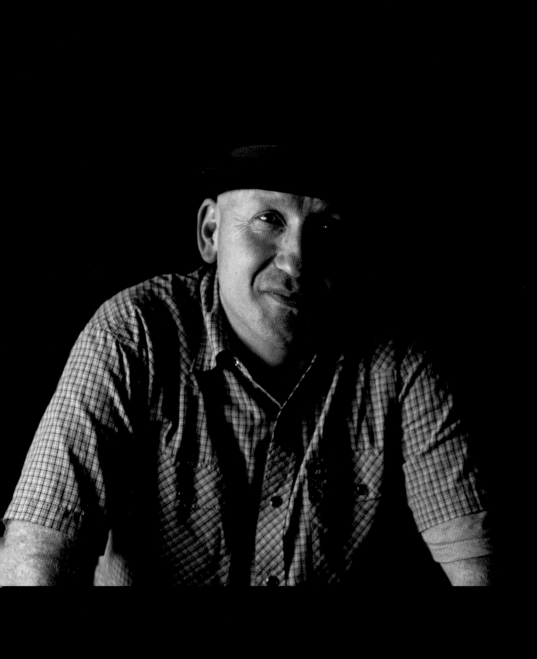

Audience

Title: Will from The Prince Albert

Photographer: Maria Short

The absence of context can
encourage the audience to consider
the significance of the subject.

The two previous chapters have touched upon
the three-way relationship between subject,
photograph and audience. Having looked at the
photograph and the subject in some detail, it is
now time to turn our attention to the audience.

In his essay, 'Brodovitch on Photography' (1969), the
highly influential art director Alexy Brodovitch states:
'Just as it is the art director who must be responsible
to an audience, the photographer, if he is to maintain
his integrity, must be responsible to himself. He
must seek an audience which will accept his vision
rather than pervert his vision to fit an audience.'

In the previous section, we looked at subject and
the importance of the photographer recognizing
their intentions behind photographic communication.
A significant aspect of this communication is
understanding the function of the photograph.
The function of the photograph can inform critical
choices before, during and after the making of
the photograph. It is equally important to have an
appreciation of who will be looking at the photograph
and the context in which it will be viewed.

While it may not be possible to predict exactly how an audience will respond to a photograph, the picture-making process can be influenced by the photographer's connection to their subject matter and clarity as to their intention. Many photographers talk about 'feeling' and 'gut instinct' as an essential part of their photographic practice; using these intuitive impulses to respond to their environment and subject. In relation to audience, it seems that these so-called 'intuitive responses' are an intrinsic part of visual language. The photographer responds to the subject, the response creates an essential component of the photograph and that is then conveyed to the audience through the photograph.

One of the greatest challenges facing a student photographer is to translate ideas into images. Just as sincerity, passion and commitment are vital to creating photographs that engage an audience; the sincerity of the photographer's intention must be underpinned by their technical application.

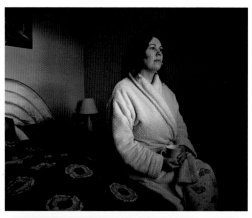

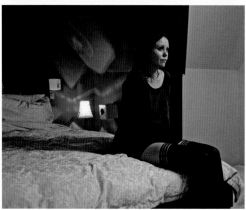

Title: *from* 'The Bedrooms'

Photographer: Emma O'Brien

In her series 'The Bedrooms', Emma O'Brien recognizes the personal interpretation the audience is likely to bring to the work, as she explains: 'For single people the bedroom is where we are truly alone. This can be an enjoyable experience or a lonely one. It can be a sanctuary or a prison, depending on the mood and disposition of the person. These images aim to convey an ambiguous mood and atmosphere, hinting at but revealing very little about the sitter. The viewer is likely to project their own experience into the photograph.'

Translating ideas into images:
problem-solving techniques

- Try to clarify your intention into a simple sentence or several key phrases.
- Examine your photographs in relation to your intention statement or phrases.
- Make a list of the essential components of one photograph.

- Cross-reference that list with your intention statement.
- Consider whether your intention needs further clarification.
- Consider whether your photographs need developing to match your intention.

Reflecting upon intention

In an article for *The Guardian* newspaper in May 2010, British photojournalist Don McCullin talked to Nicholas Wroe and described how an experience in the field caused him to reflect upon his motivations and shift his intention. McCullin explains that at first his motivations had little to do with changing perceptions: 'I was young and enthusiastic and wanted to take good pictures to show the other photographers. That, and the professional pride of convincing an editor that I was the man to go somewhere, were the most important things to me.'

It was when he was covering the Biafran war in 1969 that it occurred to him that his purpose should be to highlight the unacceptable through his images: 'It came to me in a schoolroom being used as a hospital, and I saw 800 children literally dropping down dead in front of me. I had three young children of my own. That turned me away from the Hollywood gung-ho image of the war photographer. It converted me into another person.'

In his essay on the work of photographer Keith Carter, Bill Wittliff describes a similar moment of realization when Carter began to think differently about his way of communicating photographically: '...he happened to glance up: above him the branches of a tree were festooned with tattered wind-blown streamers. To Keith they looked like wispy ghosts trying to take flight. He instinctively raised his camera just to see what they'd look like isolated in the viewfinder and he was instantly struck by the symbolism. No longer was he seeing the objects themselves, but rather the meaning – the human content – they represented.'

The key point here is that a photograph can have greater resonance than a mere record of events. Contemplate the photograph from the perspective of the intention and look at the photograph in a way that examines what is actually there and how it is presented, as that is what the audience will see and respond to. If we make the statement 'I wish to convey a sense of 'x' in my photograph, then it can be helpful to clarify in words what 'x' is and then examine the photograph asking ourselves if each component is contributing to the conveying of 'x'.

Title: *from* 'Neither'

Photographer: Kate Nolan

'They tell me I need a job, to be responsible, grow-up and be someone important. Here in Russia, at 25 a woman is supposed to have a family, home, good job, everything sorted out. Sometimes I start to believe them and then I meet someone normal like you and it changes.' – Irina, quoted in Kate Nolan's project 'Neither'. 'Neither' is an exploration into the hearts of the new generation of post-soviet Kaliningrad. Locked into dreams of a future that their homeland cannot recognize or fulfil, many Russians are searching for their identity while trapped under the weight of their history and the isolation from both their motherland and the new Europe. Left in a land that both overwhelms and underwhelms their desires, they have little ability to know their future.

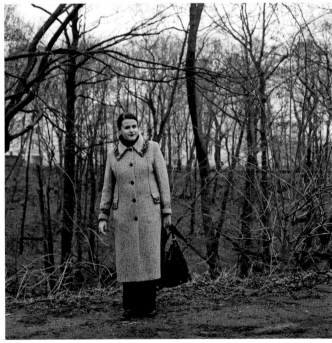

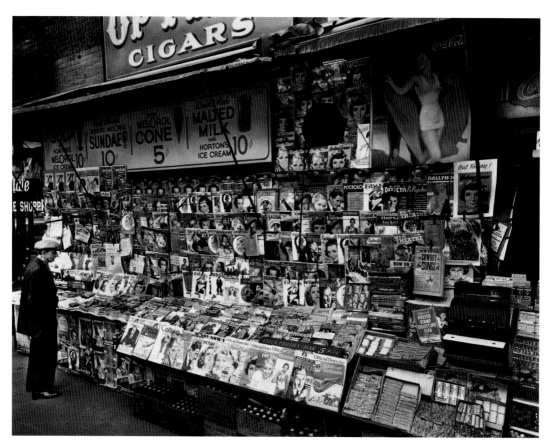

Title: News-stand; 32nd Street & Third Avenue. Nov. 19, 1935

Photographer: Berenice Abbott

In *About Changing New York*, written for the New York Public Library in 1996, Julia Van Haaften explains the intention behind Abbott's New York photographs: 'The New York images are the products of one artist's highly individual vision and complex motivations, Abbott's response to her own observations about the rapidly changing built environment and her concepts of an appropriate formal vocabulary for photographic documentation.'

Underlying passion

Berenice Abbott was very clear in her intention behind 'Changing New York', her documentation of New York, made with a Federal Art Project financial award. Abbott became interested in photographing New York in 1929 when, as a portrait photographer, she visited the city after nearly a decade in Paris and saw that the nineteenth-century city she had once called home was becoming a leading metropolis. Inspired by modernist European photography, she was eager to apply her developing visual language and creative intentions.

In 1939, Abbott explained her intentions behind 'Changing New York': 'to preserve for the future an accurate and faithful chronicle in photographs of the changing aspect of the world's greatest metropolis… a synthesis which shows the skyscraper in relation to the less colossal edifices which preceded it… to produce an expressive result in which moving details must coincide with balance of design and significance of subject.'

Elizabeth McCausland, the art critic for the liberal Massachusetts newspaper *The Springfield Republican*, reviewed 'Changing New York' and stated that Abbott's 'realistic and objective approach to the city… succeeded in creating the spirit of the city.' During an exchange with Abbott after publication of the review, McCausland expresses her thoughts on Abbott's self-expressed 'passionate' approach: 'Only from passion and fantastic passion does any sense of reality in art, or in life, come.'

So, once again, we can see the importance of an underlying passion and commitment to both subject and intention.

'The feeling we experience while we look at a picture is not to be distinguished from the picture or from ourselves. The feeling, picture, and ourselves are united in one mystery.'

René Magritte, Belgian surrealist artist

As discussed in the previous section, the photographer's intention is of great importance and will inform the flavour of the photographs. The viewer's belief in the story constructed by the photographer is influenced by whether they trust the authenticity of the photograph. Authenticity is a frequently debated notion in relation to photographs, in simple terms, however, it relates to whether the photographer is endeavouring to communicate as truthfully as possible.

Shootback

To illustrate this point further, let's look at the photographs from 'Shootback' and compare the statement of intent with the style and content of the images. The project, ultimately published as *Shootback: Photos by Kids from the Nairobi Slums*, edited by Runyon Hall, Karen Wong and Lana Wong (1999), involved giving teenagers from Mathare, one of Africa's largest slums in Nairobi, plastic point-and-shoot cameras to document their daily lives. The written introduction to the photographs in the publication is clear and simple; these are photographs made by the teenagers accompanied by their written descriptions of when and how they took each picture.

The epilogue, by project coordinator Lana Wong, explains how she was inspired to run the project and details her experiences. A statement from the United Nations outlines the rationale behind, and the impact of, the project, as do two writings by sponsor Ford Foundation President Susan V. Berresford and her South African colleague Mary Ann Burris, who writes:

'In East Africa we are well aware of the fact that our collective futures rest in the hands of our youth… Stories of mob violence, AIDS deaths, drug use, political and economic insecurity are everywhere, the stuff of front page stories about young people in our region. All these are true enough – but the images captured by the Shootback team are closer to the truth because they also depict the unconquerable human spirit and our unquenchable thirst to express ourselves.'

A further statement from the Mathare Youth Sports Association adds to a clear outline of the reasons behind and the workings of the project. The book also includes a portrait and brief autobiography for each one of the participating teenagers.

Title: *from* 'Shootback'

Photographer: Peter Ndolo

Peter says of his Shootback experience: 'I thank God and Shootback because I could have been in the street borrowing money, snatching women's bags or sniffing glue, but now I know how to take pictures, how to process film and about the Internet.'

(icon)

Title: *from* 'Shootback'

Photographer: Saidi Hamisi

One of the main qualities of the photographs from 'Shootback' is that they were made by teenagers who live in the environment that they are photographing. From the perspective of the audience, this authorship implies a sense of honesty that could not be appreciated in the same way if a visiting photographer had made the photographs.

The making of the photographs forms part of an environment and community project that has real, lasting positive effects on the lives of the teenagers and their families; it is an inclusive and value-creating project. The 'Shootback' project had a big impact on Hamisi, who comments: 'My ambition in the future is to become a good journalist.'

A clear rationale

Overall, the text accompanying the Shootback images, is giving clear information about the making of the images and rationale. Therefore, as an audience, there is no conceptual mystery to the photographs, we are clear as to their function and purpose, which means that the viewing of the photographs is placed within a clear context. The photographs themselves are a mixture of black and white and colour and take the viewer into the daily lives of the photographers in a creative and informative way through the combination of detailed interiors, portraits and street scenes; thereby covering a variety of aspects that make up the photographer's environment and convey a sense of their daily life.

The point to note here is that the photographs match the opening statement. To apply this principle to your own work and to contemplate your photograph from the perspective of your intention, it can be helpful to look at your photograph in a way that examines what is actually there and consider 'what?', 'where?', 'how?' and 'why?'. This personal reflection upon your image should illuminate major aspects of the context within and surrounding the photograph and help you think about how to develop effective visual language.

'Photography, precisely because it can only be produced in the present, and because it is based on what exists objectively before the camera, takes its place as the most satisfactory medium for registering objective life in all its aspects, and from this comes its documental value. If to this is added sensibility and understanding and, above all, a clear orientation as to the place it should have in the field of historical development, I believe that the result is something worthy of a place in social production, to which we should all contribute.'

Tina Modotti, *1000 Photo Icons* by Anthony Bannon (Foreword)

In earlier chapters, we acknowledged the relevance of social, cultural, geographical and topical experiences in influencing the audience's understanding and interpretation of photographs. Another factor to take into consideration is the attitude with which the audience approaches the image and how it will then affect them and their consequent behaviour.

Perception-shifting communication

British photojournalist Tom Stoddart's images of the famine in southern Sudan in 1998 are a good example of images that had a demonstrable effect on their audience. In *Reportage* magazine, in an introduction to the images, Colin Jacobson writes of the civilizing influence of photojournalism on humanity: 'Stoddart's photographs from Sudan belong to the tradition of photojournalism which can change the way we relate to the world.'

Jacobson continues: 'The pictures are not just visual clichés, rattled off quickly to catch a deadline. They persuade us to respond to the feelings of those who appear in them. They are the result of concern, passion and commitment, qualities which saturate the images. Stoddart is also a talented visual storyteller. And that, ultimately, is what holds our gaze.'

In another *Reportage* magazine article on Stoddart's pictures, John Sweeney outlines the direct financial result of the publication of the pictures. He explained that the pictures first appeared in the UK newspaper *The Guardian* with words by Victoria Brittain and accompanied by the telephone hotline number for Médecins Sans Frontières (also known as Doctors without Borders). The day the article was published, the charity received 700 phone calls and £40,000 ($63,000) was pledged. The same pictures then appeared in *The Guardian* weekly, the international edition of the publication, resulting in more money, including one single donation of £10,000 ($16,000) from someone in New Zealand. The photographs went on to appear in magazines in the US, Germany, France, Holland, Spain and across the world, raising awareness and financial aid for the people of Sudan.

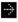

Title: A Child Cries as he is Fed by an Aid Worker in the Feeding Centre at Ajiep, Southern Sudan, During the 1998 Famine.

Photographer: Tom Stoddart

Stoddart's photographs of the famine in Sudan raised immense financial aid that proved, from a financial perspective at least, that the notion of 'compassion fatigue' was just that: a notion.

Compassion fatigue?

However, there is an opposing point of view regarding the publication of this kind of imagery. When the *Daily Express* published Stoddart's images, they were heavily criticized by the prominent British politician Clare Short for 'harping on about famine'. Short argued that situations such as the famine in Sudan require political solutions rather than individual donations and that circulating Stoddart's harrowing photographs would only result in 'compassion fatigue'. In this context, compassion fatigue is the idea that viewers who are bombarded with images and stories of suffering become cynical and unwilling to help.

Defending the publication of the images, John Sweeney observed: 'The success of Stoddart's pictures suggests that the idea of compassion fatigue is a convenient myth for those who hold political power. *The Daily Express* has raised £500,000 ($800,000). I think people respond magnificently. Readers are not morons. Let them decide.'

Context is a major component in delivering an intention to an audience for interpretation. So far, we have explored the significance of the photographer's sincerity when communicating photographically. In addition, we have acknowledged that an audience can approach a photograph with a level of suspended disbelief or a willingness to engage with a photograph and the personal beliefs and ideologies it represents. We have also examined how various social, cultural, geographical and topical influences can inform an audience's interpretation of a photograph.

When all these factors are combined, it becomes clear that, while photographers can aim to convey an intention or expression, it is not always possible to accurately predict the response of the viewer. However, the viewer's response can be informed by the photographer engaging with visual language in a manner appropriate to their intention.

Clear communication

Context can support the photographer's intention in both relating to and communicating between the subject and the audience through the photograph. From the photographer's perspective, when producing photographs and translating ideas into images, examining context can be a useful tool in illuminating whether one is using visual language to communicate as clearly and appropriately as possible.

Over the following pages, we'll return to some of the points concerning technique that we addressed in relation to subject in Chapter 2, and look at them in terms of how context can inform an audience's interpretation of an image.

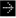

Title: *from* 'Life After Zog and Other Stories'

Photographer: Chiara Tocci

In the early 1990s, in the south of Italy, Chiara Tocci witnessed streams of Albanians docking on the coasts of her hometown after what she describes as 'a brutal and disillusive journey'. Chiara goes on to explain, 'Running away from a future they couldn't hope for, towards something equally obscure and complex, they spread all over Europe. Their stories, imagined and presumed, crowned my thoughts: whom did they leave behind and what were they longing for? After years this fascination for this enigmatic land and its people became a photographic journey for me in remote areas of High Albania.'

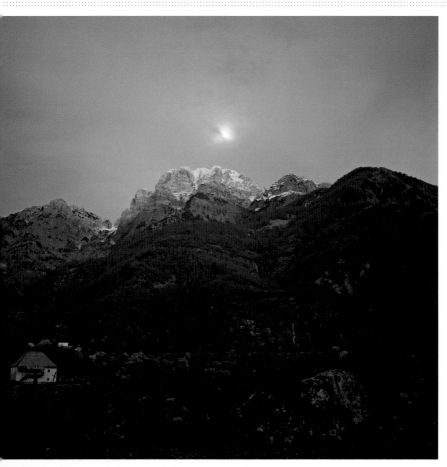

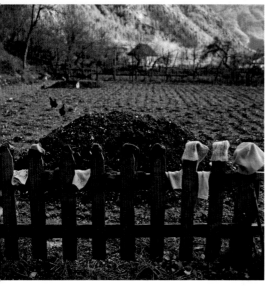

Composition and image quality

Technical image quality is a very significant aspect of visual language. Major contributing factors to technical image quality are camera format, film type and speed, lighting and exposure.

It can be enormously rewarding to visit exhibitions to see the quality of detail and exposure in a photograph made using a large-format camera and well-metered exposures. This is a great way to develop an appreciation of the relevance of technical execution. To stand in front of a well-executed print enables the viewer to fully engage with the subject and explore the concept.

If an aspect of the conceptual approach is to challenge technical quality and produce a technically 'incorrect' image, then it needs to be clear that this is intentional. A level of continuity with a coherent application of the technical approach is vital in enabling the relevance between concept and technique to be appreciated and understood.

Poor image quality

Occasionally a student will present a badly exposed or printed photograph and say, 'I think it adds to the flavour of the image'. But does it really? A bad print can look just like a bad print and is nothing more than unpleasant; potentially detracting from and devaluing the photographer's intention.

In *On Being a Photographer* (1997), David Hurn explains: 'The question one must ask oneself is, "am I translating what I see in visual terms as well as possible?" In other words, to be able to communicate, the communicator must know his craft, both technical and organizational. These are the mechanisms that help him communicate clearly. The photographer who works so clumsily at what he is trying to say that he cannot get it said, however sincere he may be, is at best still an apprentice; at worst, I'm afraid, a fraud.'

There are occasions when circumstances can inadvertently add greater meaning to an image, as is the case with the image shown opposite. Robert Capa's rolls of film were damaged during processing and many observers feel that the damage actually adds to the emotive power of the surviving frames.

'Robert Capa's iconic images of the D-Day landings could be argued to better communicate the horror of war *because* the negatives were cooked by an over-enthusiastic lab technician. Capa's pictures, and those from mobiles and videos, are so far removed from the slickness of contemporary advertising that they seem so much more like life itself, in all its fragility.'

Mark Power, 'Between Something and Nothing'

Title: France. Normandy. Omaha Beach. The First Wave of American Troops Lands at Dawn. June 6th, 1944.

Photographer: Robert Capa
© 2001 by Cornell Capa

The negatives of Robert Capa's Normandy landing photographs were dried too quickly by a darkroom assistant, and the excess heat caused the emulsion to melt and run off the film. Many frames were lost and the ones that survived were damaged and distorted by the over-heating. However, it is possible to interpret these damaged images as being more evocative of the horror they depict than they would be if they had been perfectly produced.

'Pure' photographic depiction

Jürgen Perthold created a series of photographs that were shot with a camera attached to the collar of his cat. The haphazard technical quality and composition of the images enable viewers to place them in context. This is a great example of the photographer's creative energy going into the initiation of the idea, the technical development of the camera, the implementation and editing of images, but with the photographer being removed from the actual picture-making itself. In this case, one could say that the major conceptual thrust of these images is the idea and the process.

What we take from these images is down to our interpretation as the audience. However, what we must consider is how the broader context of these images informs our interpretation. It is this broader context that not only informs, but also enables our interpretation. As photography is now so democratic, with most people either owning or having access to a camera, we are familiar with notions of truth and reality, composition and quality, not just as viewers but as makers of images. We may have experienced a slightly 'off' composition, an ill-lit image and so forth. We accept these images because they appear uncontrived by the photographer, in fact we may even perceive them as a 'pure' photographic depiction of truth and reality.

Title: *from* 'Cat's eye view'

Photographer: Jürgen Perthold

The cat camera uses a small, lightweight and inexpensive digital camera, especially designed to fix to the cat's collar and programmed to take a photograph every minute. With a fixed shutter speed and no flash, the photographs are reminiscent of the old family snapshot with occasional blurring and poor recording of colour and detail in shadow areas.

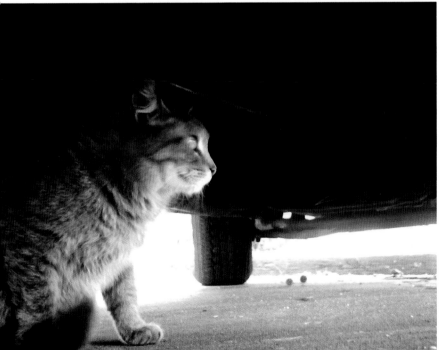

Process and presentation

The way in which an image is presented is an important aspect of the context in which it is seen and therefore interpreted. Size, shape and ordering of images are the main ingredients that inform how a series of images relate to each other or highlight the significance of a single image. We will be looking at order and sequencing in a later chapter (see page 106), so for now let's concentrate on overall presentation.

Typology sets, or series, are a simple but effective way of enabling the viewer to see the similarities and differences within a group of photographs. Typology is simply the study of types. Photography can be used in a consistent manner to produce a set of related images, as with Jamie Sinclair's images opposite, and illuminate aspects of either the subject or conceptual approach. The presentation of the typology group, such as in a grid, for example, can be an integral aspect of the interpretation and also an exercise in thinking about how viewers move from one image to another or how to use or comment upon the exhibition space.

Clarity of intent

The German artists Bernd and Hilla Becher photographed industrial buildings for more than 40 years, starting in 1959, and made black-and-white photographs of various examples of single types of industrial structures. As Michael Collins, writing for *Tate Magazine*, explains: 'There is some simplicity in which there is profound wisdom. Such is the art of Bernd and Hilla Becher... The Bechers' purpose has always been to make the clearest possible photographs of industrial structures. They are not interested in making euphemistic, socio-romantic pictures glorifying industry, nor doom-laden spectacles showing its costs and dangers. Equally, they have nothing in common with photographers who seek to make pleasing modernist abstractions, treating the structures as decorative shapes divorced from their function.'

In the case of the Bechers' typologies, the concept is found in the reading of the images based on their high-quality execution. The Bechers' strove for technical excellence and the concept is in the eye of the viewer – their 'simplicity' of production and delivery reveals the 'profound wisdom' that Collins refers to.

Title: *from* 'Constricted Reality'

Photographer: Jamie Sinclair

In these portraits, Sinclair drew upon his feelings of a loss of control over his body due to asthma. To reflect these feelings, Sinclair devised a method of photographing while his subjects were upside down and holding their breath. By doing so, he was able to capture the involuntary responses of the body.

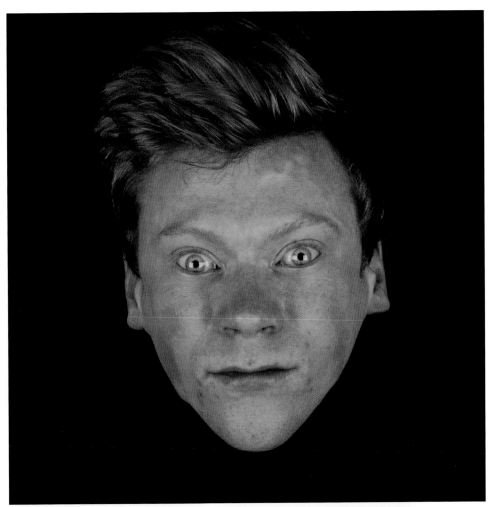

Process as conceptual rationale

In her series 'Glass', Laura Pannack's process
is the conceptual rationale behind the images,
as she explains: 'I looked at the relationship
between the subject and photographer and
decided to let photographers experience
the position of the subject. I placed a sheet
of glass between myself and the subject
to symbolize the glass of the lens, which is
the only obstacle from actual content. I then
asked each subject to close their eyes to
ensure they were unaware when I was going
to take the photograph, thereby taking away
any control they may have felt and inflicting
isolation. It relates to my thoughts on how
people often object to having their portrait
taken and how they react when faced with
the situation. I wanted my subjects to have
no control over the image as I was aware
that, as photographers, their awareness and
involvement would be much more apparent.'

Laura's work is a great example of how the
method itself can give rise to an aspect of the
audience's interpretation and is an essential
ingredient informing the presentation and
interpretation of the photograph.

Title: *from* 'Glass'

Photographer: Laura Pannack

Pannack placed other photographers
in the position of subject by using
a piece of glass between them and
the camera and asking them to
close their eyes while she made the
photographs.

'A photograph is a subjective impression. It is what
the photographer sees. No matter how hard we try
to get into the skin, into the feeling of the subject
or situation, however much we empathize, it is still
what we see that comes out in the images, it is our
reaction to the subject and in the end, the whole
corpus of our work becomes a portrait of ourselves.'

Marilyn Silverstone, British Magnum photographer

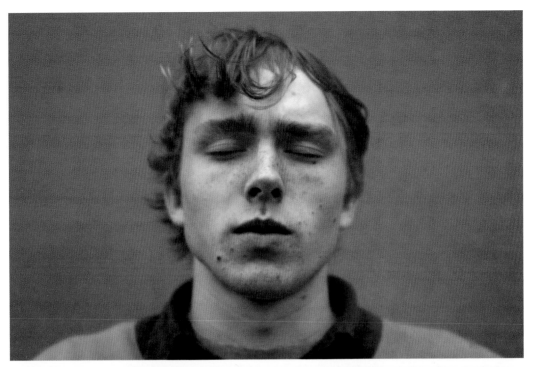

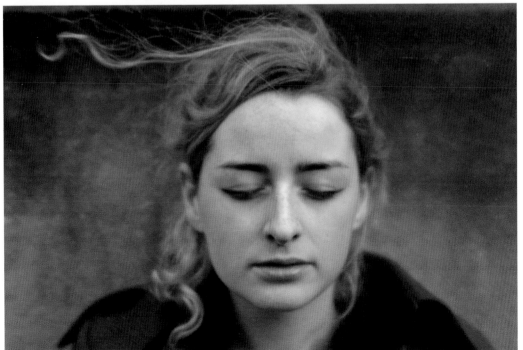

Case study

The decaying King Alfred leisure centre on Hove seafront in the south of England, UK, opened during the 1930s. Having served the public for over seventy years, the site has been earmarked for redevelopment. A Frank Gehry designed structure, incorporating a sports complex and 754 apartments, at an estimated cost of £290 million ($470 million), has been proposed for the site and is looking ever more likely to be approved by the local council. The new landmark redevelopment, designed by a world-famous architect, will soon erase the memory of the outdated, existing leisure centre.

Local photographer Simon Carruthers decided to capture the atmosphere of the original complex, before it is permanently erased from the landscape and people's memories. Using a Bronica ETRS 6x6 camera and Kodak VC160 film, Carruthers was able to use only available light in order to capture the quality of light and, through doing so, convey a sense of the atmosphere of the building. Even in the darker rooms, lit from man-made overhead lighting, one can feel the presence of the strong light reflected from the sea and the flat, open surrounding space of Hove seafront. Moving through the building from one kind of light source to another, the close proximity of the sea is felt as the 1930s building materials do not seal out the external environment and the occasional gust of wind or warm summer breeze moves through the corridors. This quality of light and sea air forms a large part of the Hove seafront experience, which could be lost in a more modern, air-conditioned building.

Title: *from* 'The King Alfred'

Photographer: Simon Carruthers

Setting his lens to the smallest aperture, Carruthers' sense of precision in his technique can be appreciated by the detail and atmosphere rendered in the images.

Aesthetic versus conceptual

Carruthers describes his attraction to the building and the intention behind his photographs: 'I was drawn to The King Alfred because, for reasons that I don't fully understand, I am intrigued by the process of decay, especially regarding the man-made. Possibly this has something to do with the gradual processes of nature reclaiming human territory. I am very aware of waste and the effect our disposable society has upon the planet. I think I could probably sense an element of wastefulness in our attitude toward this old building, which has served the community for so long.

'My ideal audience is the general public, as I see my work as informative. The last thing that I want is that my work becomes exclusive and is only understood by people who have studied the Arts. My work is conceptual – it has to be – but only to a point. If only ten per cent of the people who see it are able to make sense of it, then it has failed. My aim is to produce striking images to grab the attention but once I have your attention then it is time for the meaning of the work to come through. If the work is not striking then I won't get your attention in the first place and the work has failed. There has to be a balance – aesthetic and concept or meaning. If the work is purely aesthetic, I have little interest and if the work is too conceptual it can become self-centred or exclusive and then risks alienating its audience.'

Title: *from* **'The King Alfred'**

Photographer: Simon Carruthers

The decaying King Alfred leisure centre, on Hove seafront, opened during the 1930s. Having served the public for over seventy years, the site has now been earmarked for redevelopment.

Exercises: Consider the viewer

⟶ Prior to visiting an exhibition, look at the work online or in a book. Note your response and then compare it with your response when viewing the work at exhibition.

⟶ Take time to write down your observations and reflect upon the link between the photographer's statement, the work and your response.

⟶ Interview a friend or family member who operates outside the field of photography, discuss their reaction to a preselected range of photographs.

⟶ Swap photographs with a peer and write a description for each one, with no prior sighting or knowledge of each other's images. Write about how you feel about the photograph and in what context you think it could be used.

⟶ Try printing one photograph in several different ways; for example one large print, one small print, prints on different paper types. Discuss the impact of print size in relation to your concept with your peers.

Summary

⇢ We have brought together the key points that inform the reading of an image based on the photographer's intention, connection with their subject matter and use of appropriate visual language, technique and presentation.

⇢ Having looked at the relationship between concept and context, we could say that the photographer is required to have an awareness of the 'rules' determined by the required output and destination of the photograph. The audience will lean toward interpreting an image based on the context in which it appears.

⇢ If we look more closely at the image itself, we can see that the photographer's use of composition and their technical execution of an image provide frames of reference with which the audience can further interpret the image.

⇢ The photographer also negotiates ethical choices and defining their own personal code of practice, this arises through the photographer's awareness of their intention and the interactive process between life and their relationship with it through photography.

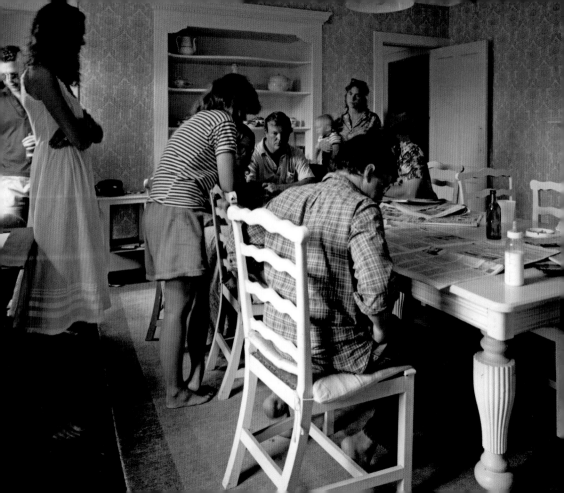

Narrative

Title: Sunday New York Times 1982

Photographer: Tina Barney

Tina Barney has said, 'I began photographing what I knew'. For much of the 1980s and 1990s, this meant taking pictures of her friends and family in their daily lives in affluent areas of Long Island, New York City and New England. Using a large-format, 8x10-view camera she creates highly detailed images that retain their focus and richness when made into 4x5-foot prints. Barney also occasionally uses supplementary lighting and directs her subjects and says: 'When people say that there is a distance, a stiffness in my photographs, that the people look like they do not connect, my answer is that this is the best we can do. This inability to show physical affection is in our heritage.'

In the previous chapter, we discussed how audiences use frames of reference and context in order to interpret the images they see. Visual narrative techniques are used to depict or create these frames of reference and context.

In photography, the aim of using these narrative techniques is to provide meaning, coherence and, where appropriate, a sense of rhythm to an image or sequence of images. These techniques can be seen as a kind of visual punctuation. In this chapter we will explore the significance of narrative technique in single and multiple images.

4

Narratives are used in many fields of endeavour where giving the audience a thread to follow or a concept to grasp can be helpful in conveying or examining information in a particular context; such as sharing experience to enhance knowledge or instigate change.

In simple terms, a narrative generally consists of a beginning, middle and end. However, a photographic narrative may not necessarily follow this structure, for example it may simply imply what has past or suggest what could happen. A photographic narrative may be a fictional interpretation of a given person, place, event or moment. As Chris Killip writes in the preface to his photographs published in *In Flagrante* (1988): 'The photographs can tell you more about me than about what they describe. The book is a fiction about a metaphor.'

In visual communication especially, a narrative does not need to work in a linear sense. It can be cyclical, or be contained within one image or make cross references that, when brought together, inform the viewer's overall understanding or interpretation of the photographer's intentions.

Linear storytelling

For example, Susan Derges' 'Full Circle' shows tadpoles hatching from frogspawn and developing into frogs. This sequence literally depicts the growth of life in a linear manner. However, this literal depiction is created and presented in a way that allows a broader interpretation of the images. Visually, the thread of information is provided as we see the steady growth from spawn, to tadpole to frog. This literal metamorphosis, combined with the beauty in the detail and sequencing of the images, can lead the audience to use the imagery as an allegory or visual metaphor.

Speaking of her work, Derges says: 'Water has been the focus of my photographic work for the past 27 years. I first became aware of the fragility and preciousness of this element when I lived in Japan in the early 1980s, while simultaneously seeing its potential to operate as a metaphor for a holistic approach to the natural world that includes our creative participation.'

'If I am looking for a story at all, it is in my relationship to the subject – the story that tells me, rather than that I tell.'

Bruce Davidson, American Magnum photographer

Title: *from* 'Full Circle'

Photographer: Susan Derges

Photograms of frog spawn hatching
into tadpoles act as a visual metaphor
for the scientific gaze.

The symbiosis of process and ideas

Derges frequently uses photograms and other methods of producing cameraless images. Looking at the images, the viewer can begin to read and make sense of what the images are 'of' because of the visual continuity found in the colour, size of subject within the print and the angle of perspective. Generally speaking, because the images maintain this level of continuity the viewer can take an overall look and see that there is a progression from one image to another. Upon closer inspection of the detail of the subject, the viewer can then realize what the prints are of, how the subject develops and begin an interpretation. Speaking of the relationship between ideas and her process Derges says:

'I am reluctant to think of myself as a photographer because so much of my work feels as if it has been to do with working with light in terms of drawing with light and dealing in a very tactile way with paper and surfaces with different kinds of emulsions. Print-maker somehow implies a very strong craft base that is not something that I am completely comfortable with either. I certainly see myself as a maker and I feel comfortable with the idea of my identity being seen primarily as a maker. The work and the ideas always come from the act of making and develop out of that rather than the other way around.'

So, as in previous chapters, we read once again of the artist citing their method of production as an essential ingredient in conveying their intention. We can imagine here, in relation to Derges' 'Full Circle', the 'maker', as she describes herself, connecting with her subject over a period of time as she made the images and during that time the spawn metamorphosing. This metamorphosis leads the project with a continually growing and evolving subject; lending itself to a rendering of a series of narrative images.

This is just one example of how narrative techniques can be used. Other methods of production and forms of presentation will be explored in the following sections.

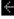

Title: *from* 'Full Circle'

Photographer: Susan Derges

The specific concerns of 'Full Circle' are natural life cycles and the relationship between the frogspawn, tadpoles and frogs and the water they inhabit.

A set or series of photographs can work together as a narrative, with the method of production and the manner of presentation giving the audience subtle visual clues that inform the reading. For example, in the photo essays typical of *Picture Post* and *Life* magazines, the 'story' is conveyed over a few pages and each photograph plays a role in informing an aspect of the story. There are several key points here for the photographer to bear in mind during the production and in planning the presentation of their work. Thinking about how the audience will see the images and how context should inform the choices the photographer makes.

For example, will you be creating a typology, as discussed in Chapter 3 (see page 86), or a photo essay with each picture showing an aspect of the story that builds to create an overall impression, or even an installation that requires a level of interactivity from the audience and 'scene setting' on your part to encourage this? Are you perhaps producing a set of photographs that can work as stand-alone images but that also take on greater relevance when presented together, or a series of photographs that depend upon an ordered sequence to show a level of development of the story or idea?

Aesthetic continuity

In Jill Cole's project 'Birds', the underlying significance of the work comes through the manner in which she photographed her subject. Cole frames her subjects so that there is a strong level of visual continuity between each image. The continuity can also be seen in the lighting, colour and tonal range of the images. The images, therefore, despite appearing quite disturbing at times, are 'easy on the eye'; there is a sense of fragility. The photographs are compelling and draw the audience in further to explore their content.

Clare Grafik, curator at The Photographer's Gallery, London, UK, writing for 2008 Graduate Photography Online for *Source* magazine, describes Cole's work: 'Jill has a very accomplished visual sensibility, which enables her to combine a number of different elements into this coherent and striking series of work.'

'A good image is created by a state of grace. Grace expresses itself when it has been freed from conventions, free like a child in his early discovery of reality. The game is then to organize the rectangle.'

Sergio Larrain, Chilean Magnum photographer

Title: *from 'Birds'*

Photographer: Jill Cole

Created over an eighteen-month period, this image is part of a series showing birds captured for scientific and conservation research on a nature reserve within an army garrison in northern England. As part of a national bird-ringing programme, the birds were caught during flight in fine nets erected between poles. Trained ringers maintained high levels of welfare throughout the process of capture, data collection, ringing and release.

A sequential story

In 'Trashumantes', José Navarro documented a three-week journey in November during which a flock of 5,000 sheep were walked across 250 miles of the Spanish landscape by their semi-nomadic shepherds. The journey saw the flock leave the exhausted summer pastures of their native Serrania de Albarracin for the green winter hillsides in Andalucia. They walked the old drovers' tracks as part of a 1,000-year-old tradition that is both cost-efficient and an environmentally friendly alternative to road transportation.

The photographs convey the enormity of the journey as the audience follows the flock through the landscape and towns. This is an example of a sequential story, the natural flow and rhythm being dictated by the event itself. As the majority of the audience viewing the images would be unfamiliar with the exact details and landmarks of the route, the order of the photographs may have been shuffled to produce a more fluid visual sequencing. Using the same camera format and tonal quality of black and white throughout enhances the level of continuity.

Points to consider in relation to narrative techniques

· How much control do you have over the order in which the pictures will be viewed?
· Will the audience see all the pictures at once?
· Will the audience follow an identified sequence?
· Will some pictures take greater prominence than others?
· Do you need a 'lead' picture – one that sums up the intention?

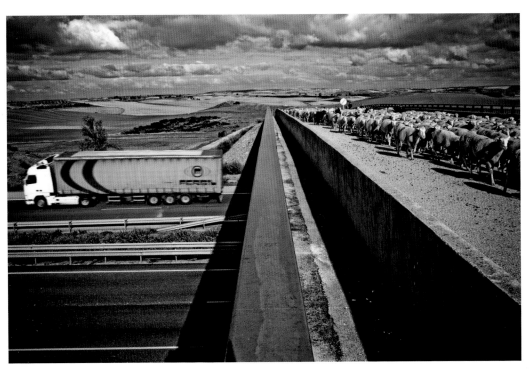

Title: *from* Trashumantes

Photographer: José Navarro

Navarro accompanied the Trashumantes (semi-nomadic shepherds) on their seasonal journey of 250 miles across Spain. He explains: 'During the journey, I felt the pervading sense of camaraderie amongst them and witnessed how the activity completely defines who they are. They are Trashumantes and could not, would not, be otherwise. Sadly, they're often seen as an anachronism in our technological society. However, for the Trashumantes, the journey is not an exercise in nostalgia but a cost-efficient and environmentally friendly alternative to road transport: they save money by walking the sheep instead of taking them in lorries. The activity is unquestionably rooted in a modern market economy.'

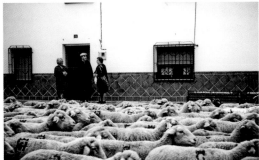

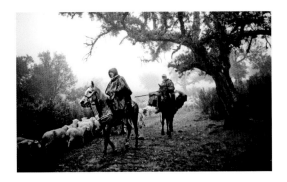

Visual punctuation

We have looked at several specific narrative techniques across a set or series of images. Other points to consider, which we touched upon in an earlier chapter when looking at presentation, are the relevance of the size and shape of the images. If you are producing a sequential set of images, it can be possible to achieve a certain pace in the series by using a particular size or shape of image at a key point in the sequence, either as a recurring theme or a one-off. This is the kind of technique that one could describe as a form of visual punctuation.

Another technique is producing triptychs and so forth; images that work as small sets within a larger body. Juxtaposing different images can also help present an argument or raise a question; the tension between negative and positive being one obvious example, and indoor versus outdoor as another.

It is also worth questioning the eye of the camera in relation to narrative. Is the camera a fourth wall, the eye of the viewer or the 'eye' of the subject, as in the cat camera of Jürgen Perthold's images (see page 85)? You may wish to extend this question and think of other perspectives that the eye of the camera could represent. It may also be helpful to look at other forms of visual communication and think how this use of perspective helps the rhythm and interpretation of the images.

We will be recognizing the relevance of signs and symbols and also text in later chapters, but it is worth acknowledging here their relevance in constructing and shaping a visual narrative.

'I am interested in the psychological space between sleep and consciousness, and how the change that occurs within that space is recorded by the bedding. Through the photographs, I capture the tension of vulnerability between the private experiences of sleeping with the public space of the hotel.'

Barbara Taylor, American photographer

Title: *from* Beds

Photographer: Barbara Taylor

Barbara Taylor's 'Beds' were produced using different camera formats over a period of time, which was largely dictated by using whichever camera she happened to have with her. What holds the project together from a narrative perspective is the subject matter; the unmade beds in hotel rooms and the variety of light.

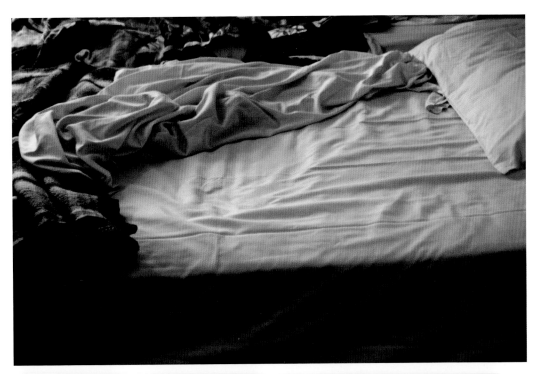

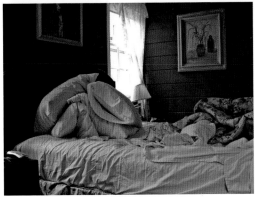

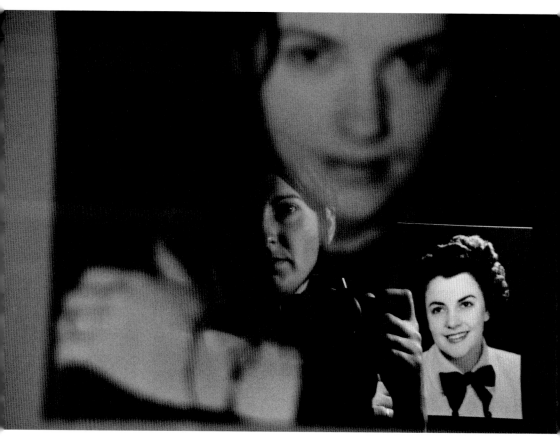

Title: Mháithreacha agus Iníonacha (Mothers and Daughters)

Photographer: Laura Mukabaa

Laura Mukabaa layered three generations of women into this one photograph in order to convey mother-daughter relationships in a single frame.

So, what exactly is narrative within a single image and how does a photographer work to convey or create it? The narrative can be drawn from all components of the picture and the dynamic or tension both of and between those components. It may be that the photograph conveys the turmoil and confusion of a moment or it may convey stillness and calm; whatever the photograph conveys, the narrative is drawn from how the basic components appear at the moment of photographing. The questions raised by this appearance of the components of the photograph could go something along the lines of: what is the picture of? What is happening? What is the relevance of the empty space/dark sky/colour of the carpet? This may sound very simple, but breaking down the various components can help the photographer to think about what they are showing their audience, how and why.

Creating meaning

In Chapter 1, we looked at the constructed theatrical work of Gregory Crewdson (see page 17). By literally constructing his images, he is clearly thinking about what he is showing his audience, how, and to a certain extent, why he is doing so. It is possible that he also had the opportunity of responding to and working with the input of his actresses. It is possible in this kind of circumstance to respond to the input of one's live subjects. For example, the subject may express an emotion in a manner that brings something unexpected but valuable to the image.

The point here is that it is important to be prepared and clear about one's intention for each photographic project. It is vital to be aware of narrative devices and their implications, while at the same time being open to unexpected elements contributing to the photograph. Ultimately, the aim of narrative technique is to provide or anchor meaning and coherence for the image and its audience.

'There is nothing inherent in any medium that guarantees its value as art. The relation between fact and symbol, expression and idea, by which we detect the presence of art in an object, is not the gift of any particular medium but is the result of an artist's negotiation with the actual world according to certain principles.'

Mike Weaver, 'The Picture as Photograph', *The Art of Photography*

Extracting single images from larger works

Some very well-known single images were originally produced as an element of a photo essay or as part of a larger body of work. For example, Henri Cartier-Bresson is now best known for his single images. However, writing for *The Independent* newspaper in 1998, Colin Jacobson reminds us of his background as a photojournalist: 'Twenty-five years after Cartier-Bresson stopped taking photographs, there appears to be a move in contemporary photo-criticism to claim his photography for the world of art and deny that he was ever a photojournalist. Cartier-Bresson himself is partly to blame for this. By extracting individual images from the context of the stories they belonged to, and re-presenting them in exhibitions and books, he has allowed himself to become best known as a photographer who produces single images.'

Jacobson goes on to describe Cartier-Bresson's coverage of Mahatma Gandhi's funeral: 'What could be a more classic example of professional photojournalism than Cartier-Bresson's coverage of Gandhi's funeral in India in 1948? Cartier-Bresson worked on 50 different events in the three days of the mourning, shooting 30 rolls of film, capturing every possible angle.'

Art as a by-product of photojournalism

American academic Claude Cookman, from the University of Indiana, interviewed Cartier-Bresson in the Spring 1998 edition of *History of Photography* and further describes his photographing of Gandhi's funeral: 'Many of his individual pictures can function as art, but he did not approach Gandhi's funeral with aesthetics in mind. Art photographers do not wade through crowds of a million and a half people. They do not demonstrate the strength and stamina that Cartier-Bresson exhibited in fighting his way to the head of Gandhi's funeral pyre.'

These single images taken from larger bodies of work can often convey the absolute essence of the intention behind the picture by capturing the vital aspects of the moment, person, event or idea. As the photographer becomes more deeply immersed in the process, the photographer is assimilating and representing the three-dimensional experience through the lens of the camera in a manner that combines their personal response to the experience and their understanding and use of visual language.

This process includes interacting with the environment while being mindful of their photographic intention, visual language and appropriate technical decisions. As Don McCullin observes: 'Even in battle photography, I go over on my back and read the exposure. What's the point of getting killed if you've got the wrong exposure?'

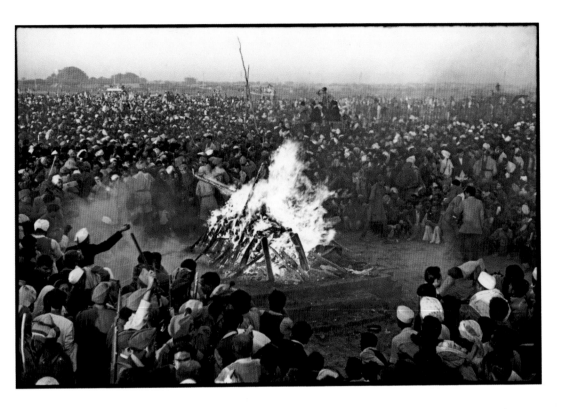

Title: India. Delhi. 1948. The cremation of Gandhi on the banks of the Sumna River.

Photographer:
Henri Cartier-Bresson

As is the case with this image, taken from the 30 rolls of film Cartier-Bresson used in photographing Gandhi's funeral, the strength of a single image may be derived from the effort and involvement of the photographer during the physical and mental process of producing a body of work.

Absolute absorption

Total immersion in the process enables the photographer to be highly tuned into the vital aspects of the photograph. In fractions of a second, the photographer can recognize how the dynamics of a moment can be distilled into a photograph that in their heart, eye and mind will convey their intention. The photographer can notice the symbolic, allegorical or metaphoric meaning between aspects of a scene that, when brought together in the frame of an exposure, made at the right time, can convey something that they have seen or intend.

As a photographer becomes more experienced in this process, it is possible to anticipate:

- How much blur a slower shutter speed will record.
- At what angle and place in the frame movement will be frozen.
- What will be sharp and what will not with a shallow depth of field.
- How and where light is falling.
- Whether to expose for highlights or lowlights.
- How many frames it will take before a moving subject is in exactly the right spot.
- Where to move oneself, or how much to shift the camera, in order to compose the photograph as they wish.

All of this in fractions of a second while still interacting with the subject and environment.

This committed absorption on the photographer's part contributes enormously to the creating of a narrative within a single image. It is this interactive process and total immersion that 'makes' the photograph. As Henri Cartier-Bresson explains: 'To take photographs means to recognize – simultaneously and within a fraction of a second – both the fact itself and the rigorous organization of visually perceived forms that give it meaning. It is putting one's head, one's eye and one's heart on the same axis.'

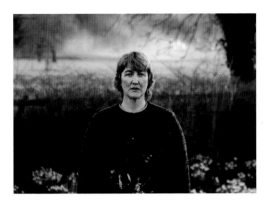

Title: *from* Derry Road

Photographer: Lydia O'Connor

'Derry Road' is a study of a community of people living along a six-mile road that runs through Kildare in Ireland. The central theme of this work explores how a community shapes the landscape around them and how this landscape shapes them. This single image, although belonging to a larger body, can convey quite simply the essence of the project's intention, as there are quite clear visual links between the subject and her environment.

Studio and still-life photography

Even in studio or still-life photography, the photographer can become so involved with their idea and subject that the most simple of objects can become a whole world and speak to them in their code of visual language. Thinking about and contemplating the composition, lighting and the relationships between subjects will enable the photographer to convey the narrative within an image or between images.

For example, in his book *John Blakemore's Black-and-White Photography Workshop* (2005), Blakemore reflects upon his journey and time spent photographing tulips: 'I spent much time just contemplating the flowers, with the camera far from my thoughts. I delighted in the tulips' voluptuous presence. Such periods of contemplation, of visual pleasure, are always a necessary part of my work process. It is a deepening of my experience of, and of my relationship to, my subject.'

Title: Untitled (The Watermill, Korana Village) *from* 'Vražji Vrt' ('The Devil's Garden')

Photographer: Eleanor Kelly

This ongoing project focuses on the inland area of Croatia through which the river Korana flows from the lakes and waterfalls of Plitvice Jezera to the renaissance town of Karlovac. This image could stand apart from, or represent, the body of work as it contains clues to beliefs and circumstances within the region.

Title: *from* 'Average Subject'

Photographer: Kim Sweet

The title of the series, 'Average
Subject', is taken from a setting on
the vintage camera used, midway
between 'dark subject' and 'light
subject'. The handbook to the camera
goes on to suggest this setting be
used for: 'Garden and river-bank
scenes, full-length people in clothes
of medium tone, well-lit scenes.' The
title neatly links the concept behind
the project with the technique used.

Case study

Kim Sweet graduated from Central St. Martins School of Art, London, UK, in the late 1980s. In 2010, she wanted to return to photography as a creative medium and in doing so reignite her visual voice and develop her technical skills alongside her way of seeing and interpreting the world around her.

Having moved from London to Eastbourne, a south-coast seaside resort famed for its popularity as a retirement town, Sweet wanted to document her new home town as a way of getting to know and explore her environment. In particular, this included the space between her home and the pier, a distance of about one mile. Sweet's underlying intention was to better understand the town, its population and visitors as well as its perceived reputation. Aspects of the town and seafront have remained relatively unchanged over the last 40 or so years, but are now slowly disappearing and being replaced with a more modern identity. The friction between old and new (or young) provided a challenge in determining the subject matter for each image and how it might be documented.

Starting out with an Olympus OM-1, 35mm camera and black-and-white film, Sweet exposed approximately two rolls of film each week over a ten-week period. As the season changed from spring to summer, so did the quality of light, the visiting population and use of the seafront. Sweet's ideas began with photographing visitors, as couples, solitary figures or as clusters, meeting or making friends. The prevalence of memorial benches on the seafront made it a useful location as it was used as both a social space and a place for reflection.

Experimentation

The small details of the seated figures that Sweet was drawn to, such as their hairstyles, hats, scarves and holiday wear, lost their resonance in 35mm black and white; they became too dated, too obvious. Instead, by experimenting with medium-format and vintage cameras, Sweet began using an old Kodak camera bought from a local charity shop. The combination of the predetermined distance of point of focus with colour film and Sweet's choice of subject matter, produced soft images, evocative in quality of holiday snaps from the 1970s (coincidentally when the camera was first in production).

As Sweet comments: 'It took me a while to understand that I was trying to slow down documentary, "street photography", in order to find what Gerry Badger describes in *The Pleasures of Good Photographs* (2010), as a "quiet" approach, that could elicit rather than prescribe this space and a particular generation of people who visit or inhabit the town. I wanted to look at a phase of life we will all inevitably enter as much as our desire to retain or remember that which becomes familiar to each generation. Although I began by photographing people, ultimately the place where the information I was trying to find was in the public and private space of gardens, homes and hotels, many of which have retained a particular quality. I wanted to make images that could resonate this sense of age – to observe without judgement.'

The point to note here is that Sweet did not settle for the obvious pictures that she made in the first few weeks of the project. She kept returning to her chosen location and continued to experiment and explore her ideas further. One of Sweet's central themes was to observe without judgement and this manifests through her chosen technique and 'quiet' images.

Title: *from* 'Average Subject'

Photographer: Kim Sweet

The narrative in Sweet's images is informed by her 'quiet' approach and use of an old 1970s camera that, when combined, provide a visual coherence to the images.

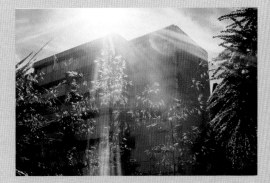

Exercises: Deconstruct the narrative

→ With your peers, take turns editing each others' work. Rearrange and regroup a set of 10–15 prints each. Observe how, with a different arrangement, the prints can convey a variety of narratives dependent upon the sequencing and their relationships with each other.

→ Choose a body of work from any photographer and describe in around 1,500 words how each image informs your overall interpretation. State the context in which you view the size, shape, colour and tonal quality. Make links between the 'facts' of what you see in terms of what is actually there, how you interpret the relationships between images and what, if any, impact that has upon your reading.

→ Choose a Tina Barney or Annie Leibovitz photograph (see page 96). Look carefully at the picture and write 1,000 words about the image. Draw upon the content, composition, lighting and dynamics within the image to describe the narrative and your response.

→ Try the above exercise with a peer with you both writing about the same photograph. Do not discuss the image until after you have written your reflective response. Read each other's writing and then discuss similarities and differences in your interpretation. Try to develop the discussion by exploring the reasoning behind your responses.

→ Look at a body of work by any photographer. Read a review of or an introduction to the work after you have viewed the images. Think carefully and make notes of how much influence text and the writings of others can have over your interpretation.

→ Watch the 1962 film *La Jetée* by Chris Marker (available on YouTube) for inspiration in using narrative techniques.

Summary

→ We have looked at narrative techniques within single images and series of photographs.

→ We have acknowledged, once again, the underlying importance of the photographer's intention informing choices in relation to appropriate methods of production and narrative techniques.

→ By linking to presentation, we have recognized that the context an image is viewed in will also contribute to any narrative.

→ The photographer's active involvement with the process of making the photograph will be shaped by asking the questions what?, how? and why?, which can provide coherence and anchor meaning.

Signs and symbols

Title: *from* **'The Consumed'**

Photographer: Christine Hurst

'The Consumed' is a body of work that explores an area of woodland once used as a location for a tuberculosis sanatorium. The work is a reflection of inherited accounts and was inspired by reminiscences concerning the unorthodox treatments that took place in the sanatorium.

Signs and symbols are part of our everyday lives; everything from street signs, food packaging, on and off symbols and open and closed signs. Some of these signs and symbols have universal applications and require very little introduction, such as red and blue symbolizing hot and cold. Other signs, such as Morse code or sign language for the deaf, require more studied learning.

The study of signs is called semiotics and can be applied to many fields of endeavour, including linguistics, the sciences and visual arts. Semiotics can be used to illuminate visual language in an interesting, applicable and socially relevant manner. However, problems can arise if the broader backdrop of society is not taken into consideration; the context of the signs being analysed as well as the surrounding social, cultural and political conditions that inform the interpretation must all be considered.

It is the context in which signs and symbols are used and interpreted that is significant to photographers and their audience. In this chapter, we will raise key points for photographers to consider when negotiating the use of signs and symbols in their work.

5

While this book is aimed at the student photographer in the process of creating images and therefore highlights practical considerations, it is also important to be aware of the theoretical backdrop to the practicalities in order to recognize the 'placing' of one's work in relation to some key terms and debates.

The key figures to be aware of in semiotics relating to photography are the Swiss linguist Ferdinand de Saussure (1857–1913) and the American philosopher Charles Sanders Peirce (1839–1914). Their key models are frequently referred to in relation to the signified and signifier and the indexical nature of photography.

Semiotics is not the sole method of decoding, deconstructing, interpreting, reading or responding to photographs. Photographs are used for many purposes within many contexts, each with their own frames of reference. For example, a photograph can also be read:

- As a piece of evidence.
- In relation to the photographer's intention and context.
- Through referencing process and technique.
- As an examination of aesthetics and traditions in art.
- In relation to class, race and gender.

Semiotic models and terminology

Ferdinand de Saussure and Charles Sanders Peirce were both developing their models of semiotics at around the same time. De Saussure used a 'dyadic' or two-part model of the sign. He defined a sign comprising of:

- A 'signifier' (*signifiant*) – the *form* which the sign takes.
- The 'signified' (*signifié*) – the *concept* it represents.

Peirce used a triadic or three-part model:

- The *representamen*: the form that the sign takes (not necessarily material).
- An *interpretant*: not an interpreter but rather the sense made of the sign.
- An object: to which the sign refers.

Roland Barthes, the French literary theorist, philosopher, critic and semiotician (1915–1980), was sensitive to the subtle nuances of photographic visual language; he recognized that when personal significance is communicated to others, it can have its symbolic logic rationalized. *Camera Lucida,* which he began writing in 1977, the year his mother died, is an exploration of the complicated relations between subjectivity, meaning and cultural society. Two key concepts he offers in *Camera Lucida* are:

- The *studium*: the general enthusiasm or polite interest in the photograph.
- The *punctum*: that which arrests attention, dependent upon the individual; that 'which pierces the viewer'.

Title: *from* **'The Spectre of an Impossible Desire'**

Photographer: Emma Blaney

Blaney explores the meaning that is often invested in small, everyday objects: 'The desire is to remember and to be remembered. This project focuses on small, everyday objects that often go unnoticed. But it is objects like these which are often, for individuals, triggers for deeply embedded memories of people/moments from their past.'

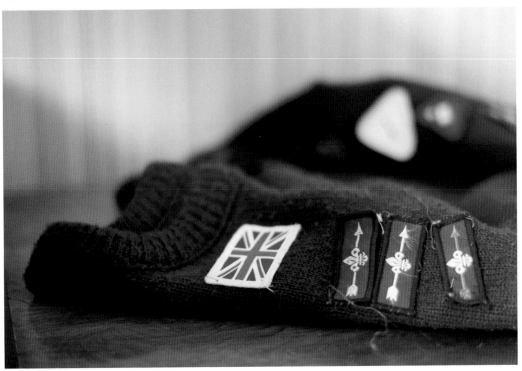

Symbols and icons

Several key points to bear in mind when approaching semiotics are the recognition and understanding of: the meaning of the signified and the signifier, the difference between a symbol and an icon and, perhaps most importantly to photographic theory, the 'indexical nature' of the photograph.

A symbol is something that represents something else. In this instance, the signifier does not resemble the signified. The relationship must be learnt, as is the case with languages, numbers, Morse code, traffic lights and flags.

Icons are slightly different, in this case the signifier is perceived as resembling or imitating the signified; being similar in possessing some of its qualities, such as a portrait, a cartoon, a scale-model, metaphors, sound effects and imitative gestures.

'Photography for me is not looking, it's feeling. If you can't feel what you're looking at, then you're never going to get others to feel anything when they look at your pictures.'

Don McCullin, *Sleeping With Ghosts: A Life's Work in Photography*

Indexicality

An indexical signifier is physically or causally linked to the signified. This link can be observed or inferred. For example, natural signs include smoke (indicating fire or heat), thunder (indicating lightning) and footprints (indicating footsteps). Similarly, physical symptoms such as pain, a rash or a raised heartbeat can all be signs of a related medical problem.

Indexicality, as described by American Philosopher Peirce, is particular pertinent to photography simply because a photograph is a literal 'trace' of its original subject. This indexical link between subject and image generates complex critical analyses of photographs and photographic debate.

The German-Jewish critical theorist, Walter Benjamin (1892–1940), wrote *A Short History of Photography* in 1931 and *The Work of Art in the Age of Mechanical Reproduction* in 1963, in which he addressed the impact of photography on the handmade work of art. He raised two major points for discussion; the ability of technology to reproduce and the manner in which the camera represented the world.

What is important here in relation to the key terms and the indexical nature of the photograph, is an appreciation by the audience that because they are looking at a photograph they will engage with notions of truth and reality that arise simply because of the chosen medium itself, regardless of its function and intention.

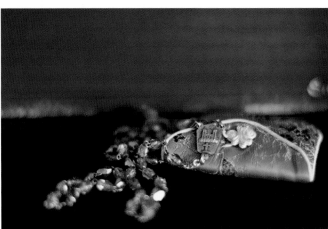

Title: *from* 'The Spectre of an Impossible Desire'

Photographer: Emma Blaney

While Barney's project uses specific people and includes quotes from them explaining the significance of each object, her project has a broader appeal because having a possession of sentimental value is something that many individuals can relate to. This is highlighted by her choice of composition; the objects themselves being the main focus of each image.

How does a photographer negotiate the use of signs and symbols in their work? Many photographers say that they respond intuitively to the moment, situation or event, while simultaneously being mindful of their intention. Others may consciously and carefully construct an image either before, during or after the event of the act of photographing. Alternatively, some photographers argue that there is no such thing as 'intuition' and that instead they respond to their subjects with an experienced, personalized sense of visual language. They believe that this visual language develops through a combination of living in an environment and using imagery as both a consumer and a visual professional.

The appearance of a sign or symbol in a photograph may or may not have been a predetermined and orchestrated consideration of the photographer. A photographer working on a carefully constructed set will have the time to consider and bring in signs and symbols.

A photographer working in a more journalistic or reportage manner may need to make more on-the-spot decisions. If the photographer is clear as to the function, purpose and intention behind the photographs, these decisions are easier, especially if they have chosen to photograph their location and subject because of the signs and symbols that they offer.

The photojournalist may have one attempt at making a particular image, so the decision as to the symbolic components to include may be more crucial than when there is an opportunity to make a series of differing compositions. The appearance of the signs and symbols may be the result of a considered decision to use them in a specific manner in one image or a series or set of images, or it may be a more loose inclusion that ranges across a series of images as the photographer responds to each individual location or subject.

Title: *from* 'Sense of Place'

Photographer: Maria Short

In 1993, my stepfather was diagnosed with serious kidney failure and put onto dialysis. He was a market grower and so the time he spent in hospital away from his crops, during his crisis period meant that much of the harvest was left to over-ripen and decay quietly crept in. Visually, I could see clear links between the life of the crop outdoors and his new life indoors as he adjusted to the dialysis.

Symbolic meaning

Robert Frank's *The Americans* is a body of work that is frequently referred to when exploring symbolic meaning within the photograph. Sarah Greenough, Senior Curator of Photographs at the National Gallery of Art (Washington, D.C.) describes *The Americans* as: 'generally considered to be the single most important book of photographs since World War 2.'

Frank divided the book into four parts, each part starting with a photograph featuring a flag. Each part of the book addressed a different aspect of American culture. With an introduction by Jack Kerouac, 'The Americans' is recognized as challenging the American post-war identity.

The photograph entitled Political Rally, Chicago 1956 begins the fourth and final part of the book. Greenough describes the photograph: 'Notice the way the tuba has completely obscured the face of the person behind it, as if to suggest these symbols of American democracy; the marching band and the bunting above it has drowned out the voice of the average American who stands behind it.'

We can see from Greenough's reading of the image how aspects of a scene can be framed within an image to convey, whether intentionally or not, a meaning that goes beyond the mere recording of a scene.

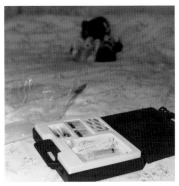

Title: *from* 'Gall'

Photographer: Maria Short

'From the moment man chose him to be the companion of his infinite enterprise, the horse was quick to reflect the style, taste, and inclinations of each civilisation in his own physique, gait and even colour.'
Luigi Gianoli, *Horse and Man*

Gall – a painful swelling, especially in a horse; a sore due to chafing; a state or cause of irritation; a chafed place; a bare place; a flaw; a fault or a dyke; to fret or hurt by rubbing: to irritate; to become chafed; to scoff.

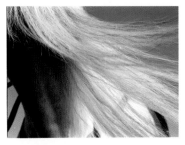

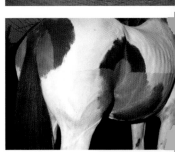

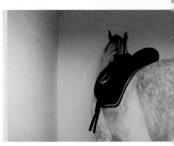

A visual metaphor

'Gall' was a project undertaken in 1994–1995 with the idea behind it to use the horse as a visual metaphor to express how I felt about the challenges that faced young women in relation to their sense of identity and social placing. Photographing in a range of locations and settings over a period of six months I developed a visual language that suited my intention and methodology. The approach to the signs and symbols in each image was to photograph them in such a way that, when presented as a series, they would collectively express my thoughts while raising questions, such as: when is protection suppression? When is freedom a cliché? This 'hidden' structure or approach was never intended to be didactic, but to rather convey the essence of my ideas and acknowledge the dilemmas surrounding expression and representation.

Responding to signs

As the project developed, I would spot something while photographing on location and often make a mental note to look for it again in the future. For example, I noticed the 'freeze mark', of the security numbers on a horse's back on one occasion but the conditions were not conducive to a clear photograph, I kept an eye out and was ready when a more appropriate moment came up.

I found these symbols hard to explain but, when pieced together photographically, they seemed to make sense. In another image, the obvious idea behind the branding of the letter 'P' is one of being 'given' or 'assumed' to have a particular identity, such as in the literary use of 'branded'. However, if I were to raise this idea visually it required more than just a photograph of the branding itself: I needed the environment, the lighting and the horse to work so that the dynamics of the image brought the symbol into question.

The photograph of the branding 'P' was made in a stable that the horse was in when I arrived on location. I asked to make the photograph before the light changed or the horse was brought out, I chose to meter for the strong available highlights, allowing the rest of the horse to be under exposed and disappear. This technical approach created an image that, for me, spoke about the true identity being hidden and only the branding being visible.

'The viewer is engaged with a place beyond the visible. Everything shifts as you move and different things come into focus at different points of your life, and you try to articulate that.'

Chris Steele-Perkins, British Magnum photographer

**Title: *from* Sakura
(Cherry Blossom)**

Photographer: Risaku Suzuki

In his essay on the work of Suzuki
'The Photographer as Pendulum'
curator Harumi Niwa explores
the idea of: 'Capturing life, which
cannot be captured, in a photograph
and leaving a record of its being.
Photographs, which are chemical
traces of the path of light, eventually
fade, their images disappear, only
the blank white of the paper they are
printed on remaining. But even then,
Kumano, snow and cherry blossoms
will continue to exist, as the seasons
shift and change in their unending
cycle. The photographer accepts
this and creates his photographs out
of the relationship of everything he
photographs – time, place, existence
itself – to himself.'

Investing meaning

As a photographer develops their project,
or response to a brief, they may find that
they are highlighting certain aspects of
their subject by photographing under
specific conditions; such as, choosing to
photograph a building at night, a landscape
during a storm or a garden during the
changing of the seasons. Particularly if
the photographer is producing a series
or set of images, it may transpire that the
particular conditions under which they are
photographing might give rise to signs
or symbols – or, indeed, the conditions
themselves may become symbolic.

For example, Risaku Suzuki photographed
the symbolic cherry blossoms during the
Japanese Sakura Celebration that takes
place every year in early spring and has
inspired artists since the reign of the
Emperor Saga in the eighth century. The
blooming of the trees after winter symbolizes
hope and strength, while the falling petals
express the fragility of beauty and life itself.

Signs and symbols can influence the
dynamics of the image itself and the
audience's reading of it. They can provide
a coherent structure for a body of work,
they can denote pacing, sequencing,
raise questions, incorporate a visual
subtext and, overall, add meaning to the
subject and its place within the image.

Environmental factors

On a trip to New York, Jane Stoggles (a professional singer and keen amateur photographer) was particularly excited by two scenes and was inspired to photograph them, as for her they summed up aspects of the experience of her time there. In both photographs, there are symbols indicative of New York and America, but what really brings the atmosphere and evocative quality to the images is not the signs alone but the weather conditions and the light. This is a simple example of the subtle nuances of semiotics and visual language.

Going back to some of the key points we addressed in earlier chapters; it is not just *what* is photographed but *how* and in what conditions. In other words, to develop ideas around sense of location or environment it is often important to take into account what Stoggles recognized in an instant; how the weather and lighting conditions of the time and place inform the atmosphere of the resulting photograph.

Title: 5th Avenue, New York and Radio City

Photographer: Jane Stoggles

The quality of light in *5th Avenue, New York* – shooting into the sun, which illuminates the flags and turns the street scene to almost silhouette – emphasises the dominance of the flag over the daily goings on. Similarly, the fog in the *Radio City* image brings a suggestive context to the image.

Experience in the reality divide

Some photographers speak of coming across images where they have no real understanding of the event or the subject they are documenting, but they make the photograph because the presence of the subject can add to their original intention or provide a flavour of their first-hand experience.

This was the case with some of the images captured by the 'Bang-Bang Club', who were a group of photographers committed to covering the reality of apartheid in South Africa. Their name was given to them in a magazine article and referred to the collective work of photographers Kevin Carter, Greg Marinovich, Ken Oosterbroek and Joao Silva.

On 18 April, 1994, during gunfire between the National Peacekeeping Force and African National Congress supporters in the Tokoza township, Oosterbroek was killed in crossfire and Marinovich was seriously injured. In July 1994 Carter committed suicide. In 2000 Marinovich and Silva published the book *The Bang-Bang Club*, which documents their experiences.

Writing for *The Guardian* newspaper in September 2009, David Smith explains how Silva and Marinovich are unaware of the full story behind two of their images:

'Silva stood before a photo he had taken of a mob beating a woman with sticks, while a passerby grinned at the camera. He did not know why they had set upon the victim. "It's one of those things you never get an answer for," he said. The picture remains an enigma.

'Marinovich showed a beautiful black-and-white image he took inside a Soweto hostel before a police raid in 1992. There, he had come across a Zulu man wearing a dress and behaving like a woman. He has never been able to work out why.'

Marinovich puts this 'not knowing' into context by explaining that: 'Writing and researching the book took us a long time and we really challenged ourselves to get to the truths, our truths more especially. Other people's truths are actually easier to get to, but digging into what you have put up as your version of reality, then digging into it more and more and challenging yourself about your perception of what really happened was quite something.'

Reflections on truth

Photographers are often faced with decisions about making visually strong images in a fast-moving environment that pose questions surrounding ethics and integrity. As we've seen throughout this book, it is therefore important for us to reflect upon notions of truth and representation.

So, these moments that a photographer can come across, although not strictly conforming to traditional notions of signs and symbols, work in a similar way: they are part of the visual language and they may, when photographed, be representative of an idea or convey the flavour of an idea. These fleeting moments can even become emblematic, metaphorical or provide motifs for much broader movements or concepts.

Signs and symbols: points to consider

· What is the function of the sign or symbol in your work?

· Are you introducing a new twist on an existing sign or symbol?

· How will you introduce your audience to the meaning of the sign or symbol?

· Does the symbol work like a recurring motif, signifying a particular mood or point to note?

· Are you expecting the audience to have pre-existing knowledge of the meaning of the sign or symbol?

· How are you framing the 'context' of your use of signs and symbols?

· Are you using any dynamics of relationships, such as juxtaposition?

'The pictures I took spontaneously – with a bliss-like sensation, as if they had long inhabited my unconscious – were often more powerful than those I had painstakingly composed. I grasped their magic as in passing.'

Herbert List, German Magnum photographer

Another method for introducing signs and symbols to photography is the use of practical techniques, such as aperture and shutter speed in relation to film speed, subject and lighting conditions. One example of this is Paul Fusco's series of photographs of the funeral of Robert F. Kennedy.

On the 8th June, 1968 Paul Fusco, then a photographer for *Look* magazine, was a passenger aboard the train carrying Robert F. Kennedy's coffin between New York City and Washington. The editor did not say anything to him about what he was expecting or wanted, he just said to 'get on the train', so Fusco did.

In a production for *The New York Times*, entitled 'The Fallen', published 1 June, 2008, Fusco explains that he was mostly focused on what was going to happen at the cemetery. As the train pulled out of New York, he was stunned to see hundreds of people lining the platforms. He responded to his instincts and got up, went to the window and pulled it down in order to photograph what he was seeing; what was happening.

The train journey took about eight hours and Fusco spent the entire journey standing at the window, photographing the people who stood at the side of the tracks. He describes the eight hours as 'a constant flood of emotion'. Fusco explains that he could not change his viewpoint or perspective; he just had 'to grab it when I could, if I could, I hoped I could'.

Technique as emotional device

Fusco describes one particular image; he could see a family standing at the side of the tracks, they had nothing with them, no trucks, cars or bikes. He had one opportunity to get the picture. Afterward, when he saw the image, he saw it as: 'real strong confirmation, to me personally, the singular powerful statement of the commitment, the effect this one man had on people and the hope he gave them.'

Fusco was using slow film which, on a moving platform, shooting moving people in sometimes low light conditions, could be a problem. This translated into the motion being captured on a slow shutter speed. Speaking of the movement in the frames Fusco says: 'The motion that appears in a lot of the photographs, emphasized, for me, the breaking up of a world, the breaking up of a society; emotionally. Everyone was there, America came out to mourn, to weep, to show their respect and love for a leader, someone they believed in, someone who promised a better future and they saw hope pass by, in a train.'

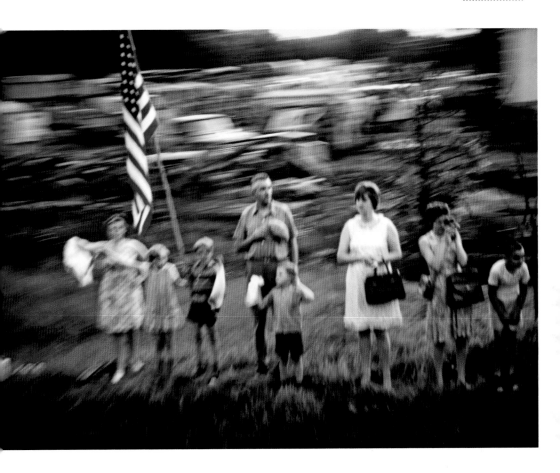

**Title: Robert Kennedy Funeral
Train 1968**

Photographer: Paul Fusco/
Magnum Photos

Fusco describes the motion as
emphasizing: 'The breaking up of
a world, the breaking up of a society;
emotionally.'

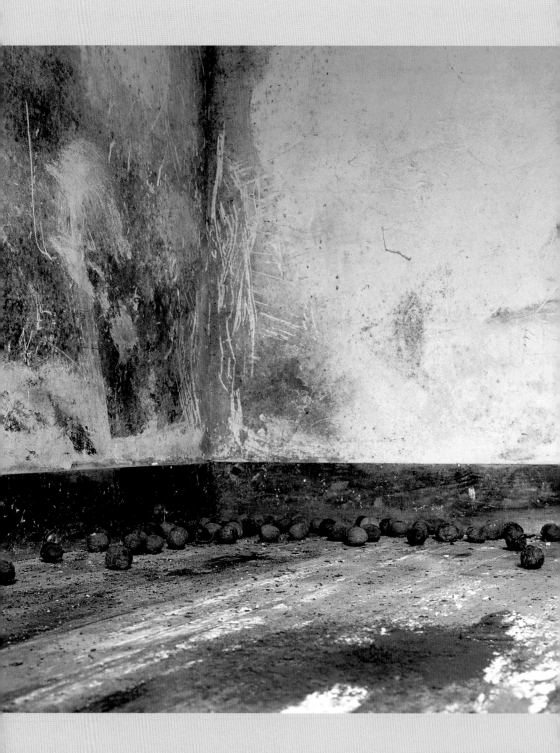

Case study

The work of Betsie Genou highlights how, even in the most simple environment, a photographer can draw upon rich symbolism, using light and a sensitivity toward their subject, to translate their ideas into poignant images.

'*Les Moguichets*' is a study of a decaying family home in France. As a child, Genou spent many of her holidays with her grandmother at her home in *Les Moguichets*. The rough translation means 'a place of decay' or 'wasteland'.

On the plot of land stood the residence of Genou's grandmother and that of her great uncle. As a child on holiday with her grandmother, Genou would play in the garden between the two houses. When the grandmother passed away, the great uncle moved across the garden into the grandmother's house and left his own home to slowly be reclaimed by nature.

As Genou was preparing to complete her photography degree, she received news of her great uncle's imminent demise and returned to spend time with her family at Les Moguichets. She was visually fascinated by the house that had been left to decay.

Using a large-format camera with long exposures, ranging from several minutes to over an hour, gave Genou the time to contemplate the past, not just her past, but the past of her family and ancestors – something that many of us can connect with if we choose. She was looking to find a universal common denominator; something that would take her project on from her own personal experiences into the realm of a shared understanding.

Title: *from 'Les Moguichets'*

Photographer: Betsie Genou

Genou's sensitive approach allows the images to draw the viewer in. This is not a short and sharp overview of physical appearances, but rather, due to the careful contemplation of composition and light, an evocative journey through a space rich with dignity despite its decay.

A personal history

In Genou's words: 'The house had been slowly deteriorating for years and was cracked in countless places; it felt like it could collapse at any time. As the last occupant of the land was passing away, I realized my family would part with this space and the memories it allowed us to visit. I began to mourn a fundamental part of my own history, and that of the history of my family.

'The idea of this project came naturally and the images were produced very instinctively. The dark mood of the photographs came from the very limited natural light that filtered into the enclosed space. Unoccupied and untouched for six years, the house seemed to have gently preserved traces of its departed occupants, which this specific light allowed me to both reveal and conceal in chosen areas.

'In relation to concept, the subject allowed me to start exploring a different aspect of what "home" had become, creating images that reflected the passing of time, and the natural concepts of life and death. The decay of the place echoed the haziness of my distant memories, and of times belonging to us which slowly flee and vanish, echoing the fragility of life.

'Exploring and photographing the space was a slow process. I used large format for quality of details, and during the long exposures I was able to reflect on the space and its memories, and to accept this imminent goodbye. This reflection was an intrinsic part of my project, and my own emotions relating to the space's history called for due time and consideration. The shooting was subsequently a slow and sensitive process.'

Title: *from* 'Les Moguichets'

Photographer: Betsie Genou

If we look at these images as they convey the photographer's relationship with the space, it is possible to recognize the subtle use of visual language, not just literally but metaphorically. The remnants of those small details of a home – a piece of crockery, a curtain, shutters, the bare walls and floorboards exposed – are all gently explored with the tranquil available light. Genou has touched upon the experiences of the viewer in a quiet manner, evocative of the history behind the project itself; the slow creeping of time and decay.

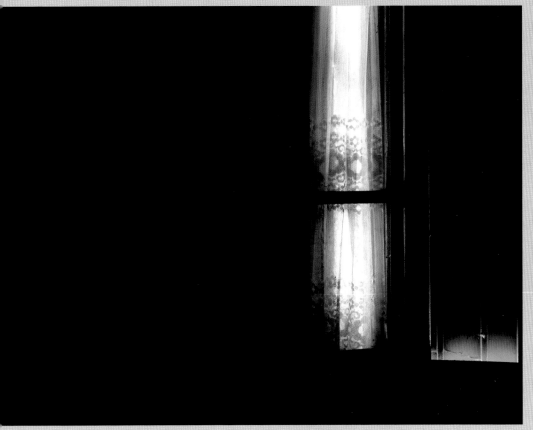

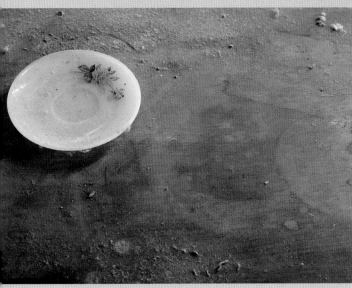

Exercises: Variations on a theme

⟿ Take a walk around your home observing how many different kinds of signs and symbols you come across. Take 20 minutes to write them down and put them into categories as detailed in the section on 'symbol, icon, index' (see page 124).

⟿ Conduct the exercise described above on a familiar route, perhaps during your journey to work, college or visiting a friend.

⟿ Look at the work of a photographer of your choice and write about a series or set of images that develop with the use of signs and symbols.

⟿ Watch Cameron Crowe's *Vanilla Sky* (2001). Note how images are used to build memory and convey notions of happiness.

⟿ Undertake a short project using a visual metaphor to convey a simple idea, such as growth or decay.

⟿ Try juxtaposing basic themes such as indoors and outdoors, hot and cold. Incorporate the passing of time.

⟿ Explore weather conditions. Incorporate a 'fixed' element into the image to give the weather conditions something to bounce off or illuminate, for example: 'the garden shed' or 'through a train window'.

Summary

⇢ The use of signs and symbols can be constructed and predetermined or incorporated as the photographer responds to their environment.

⇢ The pace and flow of narrative can be orchestrated by signs and symbols; they can be significant within the single image or provide a 'looser' link in terms of overall visual language between images.

⇢ Signs and symbols can be an integral aspect of the structure and language of images and they can provide a subtle subtext between images.

⇢ The function and purpose of the images, the approach and also the physical experience of the picture-making process, on both conceptual and practical levels, can illuminate signs and symbols.

Text

Title: *from* **'Life after Zog and Other Stories'**

Photographer: Chiara Tocci

Text appearing in the image itself can often convey how the inhabitants of an environment are relating to that environment and cultural or social issues of the time.

Captions, titles, essays and accompanying editorial text will help the audience place an image. Text, therefore, is directly related to the context in which an image is seen. A photographer may be commissioned to produce a series of images to accompany a piece of text, in this case the photographer will be considering the relationship between the image and text. For example, are the images required to illustrate the text or can they stand independently from the text and work in a more evocative manner? Alternatively the photographer may approach, or be approached by, a commissioning editor to produce images that will form the lead story with the text serving a more explanatory or questioning purpose. These are just a couple of examples of the subtleties of the relationship between image and text.

We will now go on to explore some of the main considerations regarding the relationship between text and image.

6

It is understandable for a photographer, whose main intention it is to communicate visually through photographs, to be hesitant when it comes to using text. One can question, 'If the photograph needs reams of text to explain it, then is the photograph really doing its job?'

Take a minute to reflect upon the photographs we experience in daily life and think about the role of text in relation to the photograph and vice versa. An advertising campaign may take several months, or even years, to reach the point where an audience can recognize a brand through the style and subject of images alone. Adverts therefore use slogans, captions, titles and so on to help the audience place the context of the image: this approach can also be effective in other forms of photographic work. There are occasions when a simple explanatory sentence will help the audience understand what is going on in the photograph, in a way that adds to the picture rather than negating or reducing the power of the image.

Shades of interpretation

In her book *Zoo* (1996), comprised of 74 black-and-white photographs of animals in zoos, Britta Jaschinski includes a short piece of prose, interestingly at the back of the book as a postscript. In it she writes, 'The uneasy paradoxes inherent in zoos have led me to discover aspects of myself, the animals and of a society that feels a need to confine. A stream of emotive, social and psychological associations has swept through my lens and it is precisely because of the complexities that I would never wish my images to be didactic or even complete. They cannot illustrate but do seem to embody those strains of unease, which I – and perhaps many of us – feel. The intention is to allow shades of interpretation, so that if any of my feelings, impressions and ways of seeing reflect some truth, it will be recognized by the viewer.'

Each photograph is simply captioned with its plate number, the place and year e.g. '70. San Diego 1995'. The simplicity of each caption allows the viewer to work with the profundity of each image at a personal and emotive level. The merely informative and factual caption could be said to help prevent any 'didactic' intention as to the audience's interpretation, in this way the photographer is encouraging the audience to respond to the visual language alone.

'I think that what you've got to do is discover the essential truth of the situation, and have a point of view about it.'
Burt Glinn, American Magnum photographer

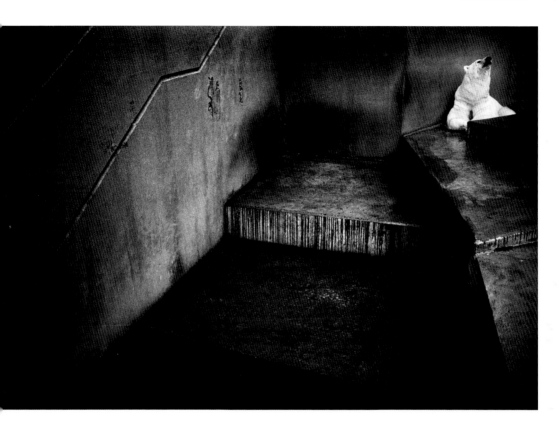

**Title: *from* 'Zoo.
Bremerhaven 1993'**

Photographer: Britta Jaschinski

Through using a factual title and being
clear about her underlying intention,
Jaschinski has allowed the images
to speak for themselves, thereby
affording the audience the opportunity
to reflect upon their own thoughts
surrounding the captivity of animals.
The simplicity of the main title 'Zoo'
and each individual title, combined
with the sequencing, technical and
creative approach, raises questions
for the audience to reflect upon.

UNLIMITED ACCESS TO VETFONE FOR £20 A YEAR.
BECAUSE DOGS WILL BE DOGS.

Joining Dogs Trust only costs £20 and you get so many benefits, including unlimited access to 24 hour expert advice from Vetfone. But most importantly, becoming a member means you'll be helping us to give life, love and a second chance of happiness to over 16,000 dogs every year. To join, call 020 7837 0006 or visit dogstrust.org.uk

Registered Charity Nos. 227523 and SC037843

Reaching an audience

In Chapter 3 we explored whether a photograph can effect social change (see page 78). It is also worth considering how the context in which an image is seen (where and how it is published) will affect the size and make-up of the audience it reaches, and therefore its ability to instigate social change. Britta Jaschinski is an example of a photographer being clear about and committed to her subject, and her photographic work has been combined with the text-based work of others. In doing so, she has broadened her audience beyond photography enthusiasts to those interested in and working in her chosen subject matter.

Title: Commissioned work for Dogs Trust

Photographer: Britta Jaschinski

In an earlier chapter we explored the importance of the photographer reflecting upon their own ethical codes of practice. If a photographer is clear as to their overall photographic intentions then it can be possible to create and pursue work that is in line with that code of practice. Here Jaschinski is working with clients whose aims are similar to and in line with her own.

The power of visual image

Randy Malamud, Professor at Georgia State University and author of books which question the exploitation of animals including *Reading Zoos* (1998), talks of his 'co-conspirator', Jaschinski at a symposium at Stanford University, CA: 'As much as I love *Reading Zoos* (I think it's the best book I have written or ever will write), I sometimes think that the most important thing it does is just present Britta's amazing photograph on its cover... Visual art is even more effective at subverting the zoo, seeing zoos as opposed to reading them and seeing them not as the zookeepers want us to see them but as they really are; showing the animals bereft, frozen; showing what animal captivity really means.'

In an interview with the Captive Animal Protection Society, in November 2009, Jaschinski says: 'I like to hear that I inspire people to take action, because I am doing the work to change something. What keeps me ticking is the hope that I am a tiny wheel in a slow movement. I have been asked many times whether I get upset when yet another photographer has 'copied' my work, to which I respond: a) there is no such thing as copying a photo because every photographer will bring something new to the subject, even if it is not consciously, and b) the more photos depicting the truth about captive animals, the better. Bigger wheels mean a faster movement!'

Literary influences

In addition to the text in the postscript and simple captions offering context to the images, Jaschinski also explains how she has drawn upon literary and artistic influences: 'I guess you could say German literature and Eastern European art by Friedrich Nietzsche, Fyodor Dostoevsky, Josef Koudelka and László Moholy-Nagy hold a certain darkness and have impacted on my "style".'

Many photographers will draw upon literature as part of their research. This background reading can inform the project, inform the photographer's approach and give rise to new ideas or avenues to explore. For example, photography student Andy Robinson responded to the set brief of the words 'Heaven and Hell' by reading around both traditional interpretations and the more metaphoric applications of heaven and hell.

As a result, he was inspired to use a lift as his space in which to photograph and explore the visualizing of emotions. Robinson's research and reading provided him with a simple structure in which to work. Having established his working methods and gained the interest of his subjects, he was able to concentrate on working with and encouraging them to engage with the ideas. This clear working structure enabled both the photographer and the subjects to explore the expressing of emotions in quite natural and interesting ways, which informed the resulting outcome.

Responding to a similar text-based brief, photography student Laura Mukabaa produced a sequence of images, each captioned with a Jeanette Winterson quote that reflected for Mukabaa the atmosphere she wished to convey of a personal internal journey. Mukabaa focused on universal emotions of loss, sadness and a desire for resolving these emotions in order to move forward. By photographing everyday scenes of the time of year and combining quotes, Mukabaa was able to extend the personal experience into a shared human understanding.

Title: *from* 'Still Time'

Photographer: Laura Mukabaa

'Even the most solid of things and the most real, the best loved and the well known, are only shadows on the wall. Empty space and points of light.'

Jeanette Winterson

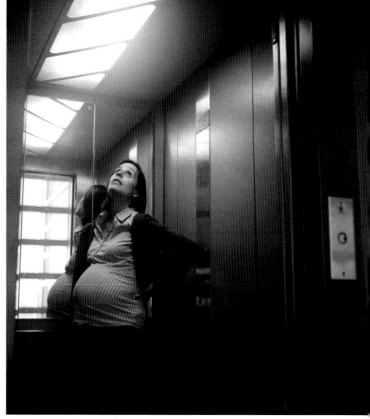

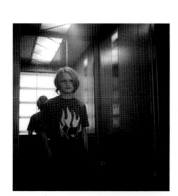

Title: Heaven and Hell

Photographer: Andrew Robinson

Robinson decided to use a lift as a symbol to represent a transitory space between the two worlds of 'Heaven and Hell'. Robinson describes the images: 'The lift is a studio and a prison to the emotions of the passenger – the doors open and these emotions or thoughts are revealed and exposed in the transition from private to public. The box shape of the lift and the 6x6 format reinforce this story.'

Another way in which text can be used as a structure for a set of photographs is as an explicitly articulated and meaningful part of the project of which the audience is aware. A good example of this is Mark Power's 'The Shipping Forecast'. The Shipping Forecast is a daily radio broadcast, first transmitted in 1922, which informs sailors of the weather conditions around the coast and seas of the UK.

As Power describes: 'The forecast was very much a part of my childhood, drifting gently across our living room from the mahogany radio gramophone in the corner, near the wicker chair which hung from the ceiling by a chain. Back then, when the choice of stations was limited, most people would listen to the [BBC] Home Service… Its strange, rhythmic, esoteric language is clearly romantic, forming an image of our island nation buffeted by wind and heavy seas, which explains why everyone's favourite place to listen is from a nice, warm, safe bed.'

Power visited and photographed each of the places mentioned in the forecast, such as Cromarty, Fisher, German Bight and so on, that had become familiar to generations of listeners across the UK. The text with each picture gives the 6am forecast on the day the picture was made.

A multidimensional experience

When the work was exhibited, a sound installation of recordings of the forecast were sampled and randomly played through Roberts radios scattered around the exhibition. The significance of the brand of the radio being that Roberts was an established brand of radios, as much an institution as the stations they played. As exemplified here, both the written and spoken word can be inclusive and central aspects of a photographic body of work.

'Taking pictures is like fishing or writing. It's getting out of the unknown that which resists and refuses to come to light.'

Jean Gaumy, French Magnum photographer

Title: GB. England. Scarborough. Tyne. Sunday 25 July 1993.
West or southwest 3 or 4 increasing 5 or 6. Showers. Good. *from* **'The**
Shipping Forecast' 1993–96.

Photographer: Mark Power/Magnum Photos

Mark Power describes these 'extraordinary' moments: 'The beauty of working like this, a method which is – essentially – street photography, is that you can never be sure what will happen next.

'When at my lowest ebb, when it felt that I haven't taken a decent picture for three or four days, something extraordinary would appear from nowhere… a middle-aged man in a three-piece suit with a rolled umbrella and a fob watch playing football, while an elderly couple makes sandcastles in the foreground.'

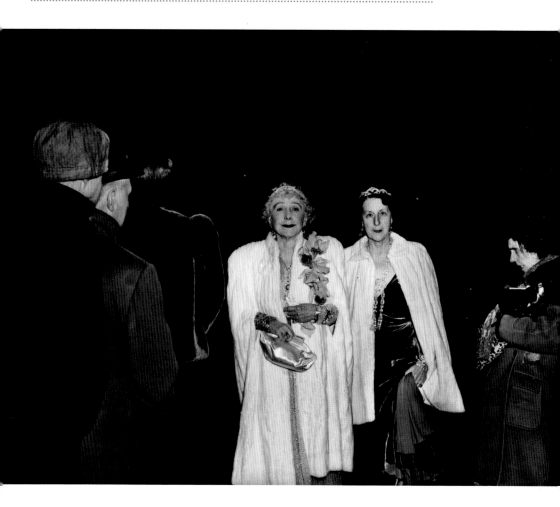

Title: The Critic

Photographer: Weegee

Weegee claimed that he only noticed the dynamics of this image during printing; however his assistant of the time, Louie Liotta, states that Weegee carefully prepared the moment. By changing the title from The Fashionable People to The Critic, he effectively shifts the audience's attention from the central figures to the woman observing them.

The significance of titles

In his photograph The Critic, photographer Weegee is reported to have set up the image in order to juxtapose the divide between rich and poor. According to his assistant Louie Liotta, Weegee requested Liotta go to a local bar and give drinks to one of the regulars and then bring the intoxicated woman to the opening just as the limousines were discharging their high-society passengers. The two well-dressed women in this photograph are well-known generous benefactors to cultural institutions. Weegee claimed to have only noticed the woman observing the opera patrons after he had printed from the negative.

The image first appeared in *Life* magazine on 6 December, 1943 and was titled The Fashionable People; it was first re-titled The Critic in Weegee's own book *Naked City* (1945). By using the title *The Critic*, Weegee encourages the audience to see the relationship between the two well-dressed women and the woman he reportedly set-up to appear in the image; after a second look it could appear as though she is 'the critic'.

The International Centre of Photography, New York describes Weegee's work as follows: 'This contrast of images, the rich with the jewels, and the well-mannered "plain people" was exactly what Weegee was striving for in all of his photography. The incongruence of life, between the rich and poor, the victims and the rescued, the murdered and the living – his photographs had the ability to make us all eyewitnesses and voyeurs.'

Loaded with meaning

In her work *An American Index of the Hidden and Unfamiliar* (2008) photographer Taryn Simon has used accompanying text with each photograph. The text is placed very precisely on the page under each image. The overall manner of presentation alludes to the 'index' of the title. Flicking through the pages of the book, the reader experiences a sense of images being 'documented', in that it is reminiscent of a filing system where each image is stored and labelled. The text itself describes the content and place of each photograph in a plain, factual manner.

Writing for *Museo Magazine*, Geoffrey Batchen observes: 'Viewing one of these works involves looking briefly at the image, then looking away to read the text, and then looking anew at the image, lingering on it, drinking it in fully once it is loaded with meaning. By that point, it is practically a hybrid of text and photograph: it is charged. Simon's brand of social realism is thus also, perhaps primarily, a form of critical practice that calls into question its own medium.'

The viewer derives understanding from the combination of image and text. Without the accompanying text, the image fails to communicate its full meaning and vice versa.

The accompanying text to the Taryn Simon image opposite reads:

'African cane rats infested with maggots, African yams (dioscorea), Andean potatoes, Bangladeshi cucurbit plants, bush meat, cherimoya fruit, curry leaves (murraya), dried orange peels, fresh eggs, giant African snail, impala skull cap, jackfruit seeds, June plum, kola nuts, mango, okra, passion fruit, pig nose, pig mouths, pork, raw poultry (chicken), South American pig heads, South American tree tomatoes, South Asian lime infected with citrus canker, sugar cane (poaceae), uncooked meats, unidentified subtropical plant in soil.

'All items in the photograph were seized from the baggage of passengers arriving in the US at JFK Terminal 4 from abroad over a 48-hour period. The JFK handles the highest number of international arrivals into the nation's airports and processes more international passengers than any other airport in the United States.

'Prohibited agricultural items can harbour foreign animal and plant pests and diseases that could damage US crops, livestock, pets, the environment and the economy. Before entering the country, passengers are required to declare fruits, vegetables, plants, seeds, meats, birds or animal products that they may be carrying. The CBP agriculture specialists determine if items meet US entry requirements. The US requires permits for animals and plants in order to safeguard against highly infectious diseases, such as foot-and-mouth disease and avian influenza. All seized items are identified, dissected, and then either ground up or incinerated.'

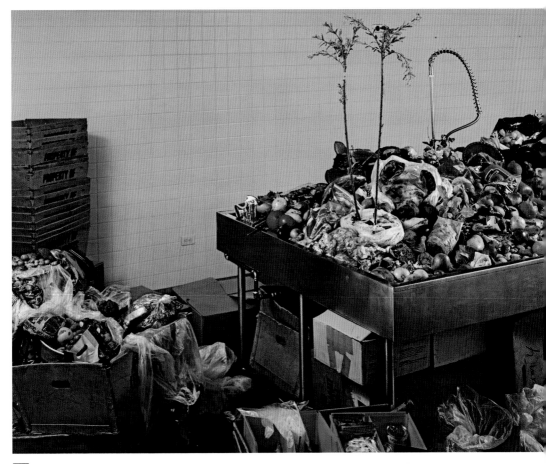

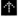

Title: U.S. Customs and Border Protection, Contraband Room. John F. Kennedy International Airport, Queens, New York.

Photographer: Taryn Simon

The relationship between the plain, factual text (opposite) and the almost clinical image alludes to the nature of the photograph as evidence. This simple approach throughout the work, combined with Simon's choice of location and also, importantly, those locations acknowledged that did not agree to participate, creates a portrait in keeping with the title *An American Index of the Hidden and Unfamiliar.*

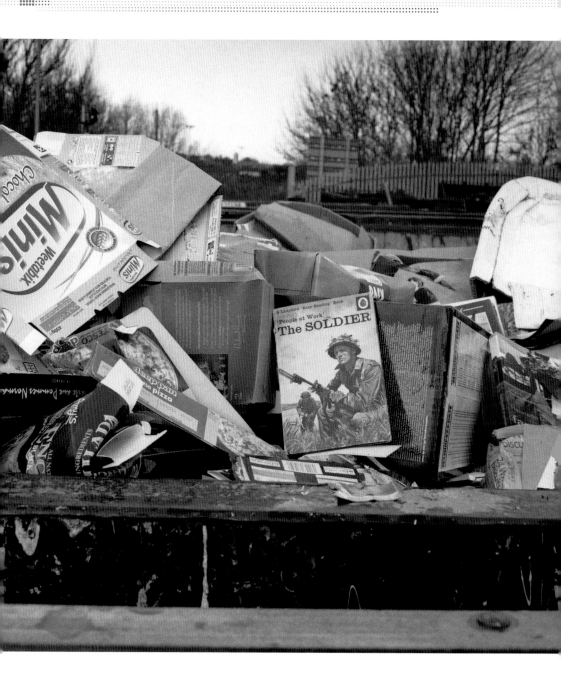

Many photographers make use of text appearing in the photographs themselves. For example, in Paul Reas' work *I Can Help*, the photograph of what appears to be a queue outside an out-of-town superstore contains the letters '*que*' in the centre background. Another of his images, from the same body of work, is a Christmas scene showing two customers waiting to be served at an empty counter, with a banner in the background reading 'Season's Greetings'. The two customers not being greeted, whether seasonally or otherwise, and laden down with shopping, creates an ironic tension to the image that questions the orientation of values and consumerism.

Similarly, Robert Frank's Sick of Goodby's is a powerful black-and-white image of his hand-scrawled text on a mirror. Liz Jobey, associate editor of *Granta* magazine and author of *A Photographic History of the 20th Century* (2000) describes the image in relation to the photographer's life experiences, his personal losses and his grief: 'Sick of Goodby's is a picture of emotional exhaustion... In this picture is all Frank's weariness. Too much has gone.'

The personality of handwriting

It is worth bearing in mind the difference between handwritten and printed text; handwritten text can bring a sense of the person and their life condition at the time of writing to the image in a way that printed text cannot. For example, Keith Arnatt's 'Notes from Jo' (1990–1994) comprise a series of messages penned by his wife and photographed by Arnatt after her death in 1996. The notes were ones that his wife had left him on a daily basis; notes reminding him at what time she was due home and so forth.

Sophie Baylis, writing for *Hotshoe International*, observes: 'the beauty behind Arnatt's work is his ability to exact pleasure from mundane, everyday objects; disposable items that are thrown away without hesitation. Witty notes such as, 'You bastard you ate my last crackers!' and more practical reminders, including 'Turn off onions if burning', not only offer a brief but poignant snapshot of the couple's life together, but also epitomize Arnatt's belief that even the smallest detail can be transformed into an object of interest or beauty when isolated in a photograph.'

Title: The Soldier

Photographer: Barney Craig

The text in this image raises questions that relate to the changing of social values; as shown by the children's book *The Soldier* being discarded.

Adding text

Multiple exposures, scratching into negatives, overlaying text when printing, composite printing a negative of text with an image negative are just a few analogue methods that can be experimented with, as well as digital photographic software that enables the combining of text into the image. Incorporating written diaries into the image, or in an appropriate accompanying format to the images, can also be an interesting method of combining text and image.

Title: Untitled

Photographer: Rhiannon Ellis

As a design student, Ellis is visually led and familiar with exploring and creating techniques that can then be applied to a brief or the concept. In this case, she was experimenting with the layering of images and was looking to see how her audience of peers responded and interpreted the visual impact, so she could file that response for future work.

Title: Untitled

Photographer: Emily Watts

Watts photocopied a page of her travel diary onto acetate and then overlaid the acetate onto the photographic paper in the easel under the enlarger just before exposing a negative onto the paper. As the exposure was made through the acetate, the resulting image combines both the acetate photocopy from the diary and the image from the negative that was in the enlarger.

Layering

Graphic design student Rhiannon Ellis chose to scan the inside of books that contained inscriptions, in this case her working method coming before the concept. In the two examples here, Ellis combined the scan of the book inscription with photographs she took herself of snow. With a conceptual direction, the combination of the two images could be used to reference past and present relationships and could be developed further as either a stand-alone image or a narrative.

Some projects lend themselves to including text in the form of a complementary journal. For example, Mike Fearey kept a written diary to accompany his year-long study of the Tenantry Down Road allotments. Using a Pentax 6"x7" and black-and-white film, Fearey photographed the allotments from 1990–1991 on a regular basis and documented, amongst other things, the slow change of the seasons. The diary recounts in a minimal manner each visit he made and points of change, development and incidents that impacted on the allotments.

The pictures are explanatory without the use of text. However, by incorporating the diary, the text adds a further dimension and includes the element of human relationships, which are inferred by, but not literally depicted, in the photographs.

Two entries read:

Wednesday, 21 November, 1990.
Time 11.00 am Shooting 1/125th sec.
F5.6 – f8.

Bright, cloudy day. More people about today. Not spoken to anybody today. Carry on shooting sheds.

Saturday, 12th January, 1991.
Time 2.48 pm
Shooting: 1/125th sec. F16.

First visit to Tenantry Down Road in 1991. Beautiful sunny day; no clouds but with a northerly wind. Not many people around at the present time. Everything looking very dormant. Horse manure brought to the site on New Year's Day. Met Caroline. I talked to a young chap who has a plot near to his father's on the upper slope. Had all the glass on his shed broken but the vandals could not break down his metal inner door – nothing was taken.

Title: *from* **Tenantry Down Road Allotments**

Photographer: Mike Fearey

Fearey's simple and practical approach takes the viewer on a journey through the allotments. The difference in viewpoint of each image suggests that it is not so much the structures and pieces of land that should be compared or examined in detail, but rather how the land and its inhabitants together work as a changing, seasonal and rhythmic whole.

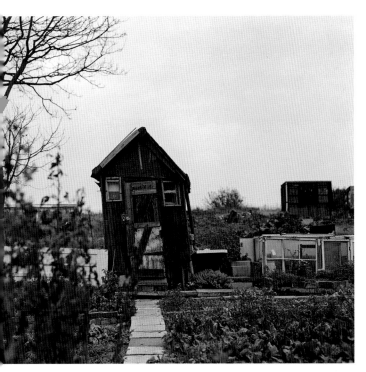

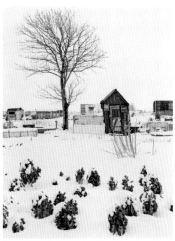

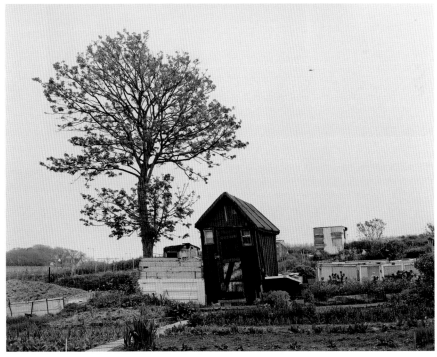

Title: *from* 'Uncertainty'

Photographer: Trevor Williams

'Drawn by my eager wish, desirous of seeing the great confusion of various strange forms created by ingenious nature, I wandered for some time among the shadowed cliffs, and came to the entrance of a great cavern. I remained before it for a while, stupefied, and ignorant of the existence of such a thing, with my back bent and my left hand resting on my knee, and shading my eyes with my right, and often bending this way and that to see whether I could discern anything within; but this was denied me by the great darkness inside and after I stayed a while, suddenly there arose in me two things, fear and desire – fear because of the menacing dark cave, and desire to see whether there were any miraculous thing within.'

Leonardo da Vinci (1452–1519), Renaissance painter, scientist and philosopher

Case study

Trevor Williams' great passion is quantum physics, the branch of physics concerned with describing the behaviour of subatomic particles. His 1997 final year photography degree show 'Uncertainty' draws upon this passion. Williams' aim was to respond to the subject with a series of photographs and communicate his visual understanding and interpretation of the main principles of the theory in a way that did not literally illustrate them, but which was evocative of the essence of the concepts involved. The intention was for the audience to engage with the idea of quantum physics through the photographs. Williams devised a strategy to photograph everyday scenes and objects in a way that would bring the viewer's attention to how light can illuminate the existence of matter.

While experimenting with his technical approach Williams considered his final presentation and the use of text. He could have simply offered an introduction to the photographs that explained in simple language some of the basic thinking behind quantum physics and the intention of the project. However, this approach could become overly personal with little relevance to the viewer or create the opportunity for a lack of coherence to the images; so Williams searched for a structure that would hold the images together.

Interpreting words and images

After much discussion and sharing of his experiments with his peers, Williams came up with eleven key points to photograph and present. He decided to use the letters of the word 'uncertainty' screen-printed onto a white board with each one of the eleven, 20cm x 20cm (8" x 8") cibachrome prints laminated onto foam board and placed under each letter. Below the images was a piece of text by Leonardo de Vinci (see previous page) and arranged so that each image had a corresponding column of words below it. The frame measured 61cm x 2m 34cm (2' x 8') and 5cm (4") deep, with a custom-made mount.

Williams explains: 'The intention was to question the ideas of absolute knowledge – by playing with the conventions of how we view and interpret words and images – methods by which we gain much of our knowledge. When one first looked at the columns of words under each image they appeared to be random words, however if one read across from one column to another it made sense. I used this method of presenting in order to echo my intention. I wanted the audience to work out how to see the images and text.'

The danger with a project that draws upon complex scientific or philosophical issues is that it can be difficult to engage in a critical debate of the photographs because the nature and complexity of the subject either obstructs debate or the intention behind the images negates any critical debate through being self-affirming or evasive.

The key to a successful outcome with this project was Williams' active participation in a community of photographic practice and his in-depth understanding of quantum physics. Through regular discussion with his peers, Williams was required to verbally communicate his intention, which in turn helped him define his ideas clearly. Williams' systematic approach to making photographs, bringing them to seminars, sharing ideas and receiving and then acting upon the feedback with new photographs was a disciplined and proactive working method that enabled him to develop the work. The final presentation is an example of how a simple image text relationship can communicate complex ideas.

Title: *from* 'Uncertainty'

Photographer: Trevor Williams

Two of the final eleven images that were presented in one bespoke frame; the title 'Uncertainty' running across the top of the photographs and the text by Leonardo da Vinci in columns underneath each image. At first glance it appeared the text was a random selection of words, however, if read from left to right the meaning appeared. Using this style of presentation echoed the conceptual drive behind the work.

Title: *from* 'Collapsing the Wave Function'

Photographer: Trevor Williams

Williams has continued to develop ideas from 'Uncertainty' and is currently working on a long-term project 'Collapsing the Wave Function', a term taken from quantum physics theory. Inspired by the manner in which photographers used to emboss their copyright onto the borders of analogue hand-printed photographs, the text is embossed on each image, in the bottom left-hand corner; compiling copyright details, project description and the mathematical formula for collapsing the wave function.

Exercises: Using text

⇢ Watch Alan J. Pakula's 1974 film *The Parallax View*, specifically the 'test film' sequence. Observe the use of text, sound, sequencing and shuffling of images in relation to the text. Also, see if you can spot some well-known photographs.

⇢ Produce a short 'test film' sequence yourself in the style of *The Parallax View*. Choose a theme or a point you wish to make. Present your sequence to your peers and discuss their response in relation to your intention.

⇢ Look at three different photographers of your choice and write a 1,500 word short comparative essay on their use of text.

⇢ In groups with your peers, swap prints with their titles removed and take it in turns to re-title each print. You could devise a system of five or so contexts in which the prints could be seen and produce a different title for each print. Share your results and discuss.

⇢ Choose a short piece of text from a piece of prose, poem or song and use it to initiate a short project.

⇢ Experiment with multiple exposures, analogue and digital post-production techniques to combine image and text.

Summary

⟶ A variety of methods can be used to combine image and text. The important point to remember is the underlying intention, conceptual approach and the function of the photograph. Different rationales will require different approaches.

⟶ Text can be used to enhance and add to an image.

⟶ Text can initiate an idea or provide a structure for and coherence to the images.

⟶ Photographs can illustrate text and text can also be used to explore or question photographs.

⟶ Text can be within the photograph, combined as integral part of the image, used as a title or caption or work in a traditional editorial manner. Essentially the importance of text is to support or provide an appropriate context in which to present and read the images.

'When scholars write theses and give lectures before
students and when writers or artists publish or exhibit
their works, they offer their thoughts and intentions
to their fellow men and in this way influence society
and politics. The greater the artistic or scholarly work,
the greater its influence on the times and the stronger
the likelihood that the work may pave the way for
political change.'

Daisaku Ikeda, photographer, writer, educator and international promoter of peace
Choose Life: A Dialogue

Conclusion

This book has explored how the intended function of a photograph can inform the choices photographers make in relation to their use of visual language and appropriate technical decisions. In turn, these choices shape the work as the photographer uses context and narrative devices to communicate the concept behind the photograph.

Recognizing the significance of context, and employing the appropriate narrative devices, can be an in-the-moment reflex of a photographer tuned into both their environment and their personal approach to visual language. It can also be an experimental, explorative or considered journey as the photographer uses the process of photographing to develop their own ideas, responses and creative methodology.

As Bill Jay passionately states in his article, 'The Thing Itself: The Fundamental Principle of Photography':

'If the subject of the photograph is the vehicle for profounder issues, then it is the photographer's responsibility to think and feel more deeply about those issues. … The ultimate aim is an oscillation between self and subject with the image being a physical manifestation of this supercharged interface between the spirit and the world. It demands reiteration: this conscience of the photographer is not learned, not appropriated, not discovered, not acquired quickly or without effort. It is a function of the photographer's life.'

We can derive from this perspective that the relationship between concept, subject, technique and outcome is a symbiotic and often complex experience, which extends beyond a two-dimensional image. We could say that the relationship between the photographer's internal understanding of themselves, relationship with the world around them, motivation and discipline as well as their desire to grow and develop are all manifested in their work.

Ultimately, the driving force behind the use of context and narrative should be the conceptual approach of the photographer as this will shape and inform both the process and the outcome.

Title: Missile Silos.
August 2007. From Greenham Common 2006–2010

Photographer: Richard Chivers

In the UK, during the 1980s and 90s, Greenham Common became synonymous with the Cold War and the peace protests against the storage of nuclear missiles at the site. The strength of these protests was significant and Greenham became an international icon for peace against nuclear war.

Chapter 1: The photograph

Arnold, E. (1995) *In Retrospect*.
New York: Alfred. A. Knopf.

Barthes, R. (1981) *Camera Lucida: Reflections on Photography*.
New York: Hill and Wang.

Berger, J. (2008) *Ways of Seeing*.
London: Penguin Books.

Bull, S. (2010) *Photography*.
Oxon: Routledge.

Cotton, C. (2004) *The Photograph as Contemporary Art*.
London: Thames and Hudson.

Lury, C. (1998) *Prosthetic Culture: Photography, Memory and Identity*.
Oxon: Routledge.

Meiselas, S. (1981) *Nicaragua*.
New York: Pantheon Books.

Sontag, S. (1979) *On Photography*.
London: Penguin Books.

Szarkowski, J. (2007)
The Photographer's Eye.
New York: The Museum of Modern Art.

Wells, L. (ed.) (2003)
The Photography Reader.
New York: Routledge.

Chapter 2: Subject

Evans, J. (ed.) (1997)
The Camerawork Essays: Context and Meaning in Photography.
London: Rivers Oram Press.

Hill, P. and T. Cooper. (1998)
Dialogue with Photography.
Stockport: Dewi Lewis Publishing.

Hurn, D. and B. Jay. (2004). *On Being a Photographer: A Practical Guide*.
Anacortes: Lenswork Publishing.

Jay, B. (1992) *Occam's Razor*.
Munich: Nazraeli Press.

Lifson, B. (1989) The Inner Vision. In:
D. Wolf and N. Rosenthal (eds).
The Art of Photography, 1839–1989.
New Haven: Yale University Press.

Southam, J. (1989) *The Red River*.
Manchester: Cornerhouse.

Sudek, J. and A. Fárová. (2004)
Josef Sudek: Poet of Prague: A Photographer's Life.
New York: Aperture.

Traub, C., S. Heller and A. Bell. (2006)
The Education of a Photographer.
New York: Allworth Press.

Weaver, M. (1989)
The Picture as Photograph. In: D. Wolf and N. Rosenthal (eds).
The Art of Photography, 1839–1989.
New Haven: Yale University Press.

Chapter 3: Audience

Badger, G. (2007)
The Genius of Photography.
London: Quadrille Publishing.

Bourdieu, P. (1996)
Photography: A Middle-brow Art.
Oxford: Polity Press.

Capa, R. (2001) *Slightly Out of Focus*.
New York: Modern Library.

Jacobson, C. (2002) *Underexposed: Pictures of the 20th Century They Didn't Want You to See*.
London: Vision On Publishing.

Lange, S. (2006) *Bernd and Hilla Becher: Life and Work*.
Cambridge, Mass.: MIT Press.

Levi Strauss, D. (ed.) (2003)
Between the Eyes: Essays on Photography and Politics.
New York: Aperture.

McCullin, D. (2002) *Unreasonable Behaviour: An Autobiography*.
London: Vintage.

Sultan, L. (1992)
Pictures from Home.
New York: Harry N. Abrams.

Yochelson, B. (2008) *Berenice Abbott: Changing New York*.
New York: The New Press.

Chapter 4: Narrative

Berger, J. (1989)
Another Way of Telling.
London: Granta Books.

Blakemore, J. (2005)
John Blakemore's Black and White Photography Workshop.
London: David and Charles Plc.

Cartier-Bresson, H. (2004)
The Mind's Eye: Writings on Photography and Photographers.
New York: Aperture.

Chandler, D. and R. Ferguson (2009)
Paul Graham: Photographs 1981–2006.
London: Steidl.

Derges, S., C. Cotton, M. Hall, S. Drew and D. Chandler (eds.) (2002)
Kingswood: Susan Derges.
Kingswood: Stour Valley Arts.

Killip, C. (2009) *In Flagrante*.
New York: Errata Editions.

Michals, D. Things are Queer.
In: Michals, D. (1997)
The Essential Duane Michals.
London: Thames and Hudson.

Parr, M. (1999) *Common Sense*.
Stockport: Dewi Lewis Publishing.

Chapter 5: Signs and symbols

Barret, T. (2005) *Criticizing Photographs: An Introduction to Understanding Images*.
New York: McGraw-Hill.

Bate, D. (2009)
Photography: The Key Concepts.
New York: Berg.

Benjamin, W. and J. A. Underwood (trans.) (2008) *The Work of Art in the Age of Mechanical Reproduction*.
London: Penguin.

Burgin, V. (ed.) (1982)
Thinking Photography.
London: Macmillan Press.

Frank, R. (1993) *The Americans*.
Manchester: Cornerhouse.

Fusco, P. and E. Kennedy (2008)
Paul Fusco: RFK.
New York: Aperture Publishing.

Greenough, S. and S. Alexander. (2009) *Looking In: Roberts Frank's The Americans*.
London: Steidl.

Marinovich, G. (2001)
The Bang-Bang Club: Snapshots from a Hidden War: The Making of the New South Africa.
New York: Basic Books.

Roberts, J. (1998)
The Art of Interruption, Realism, Photography and the Everyday.
Manchester: Manchester University Press. pp. 144–171.

Wells, L. (ed.) (2004) *Photography: A Critical Introduction*.
Oxford: Routledge.

Chapter 6: Text

Barth, M. (2000) *Weegee's World*.
Boston: Little, Brown and Company.

Hurn, D. and J. Fuller. (2010)
Writing the Picture.
Bridgend: Seren Books.

Hurn, D. And C. Grafik (2007)
I'm a Real Photographer: Photographs by Keith Arnatt.
London: Chris Boot.

Kippin, J. (1995)
Nostalgia for the Future.
New York: Distributed Art Publishers.

Power, M. and D. Chandler. (1996)
The Shipping Forecast.
London: Zelda Cheatle Press.

Reas, P. (1988) *I Can Help*
Manchester: Cornerhouse.

Taryn, S. (2007) *An American Index of the Hidden and Unfamiliar*.
London: Steidl.

Todoli, V. and P. Brookman (2004)
Robert Frank: Storylines.
London: Tate Publishing.

1000wordsmag.com
An online magazine highlighting the best in contemporary photography.

aperture.org
The Aperture Foundation supports photography in all its forms. This online resource details exhibitions, books, magazine, lectures and other Aperture-supported activities.

bjp-online.com
The British Journal of Photography was established in 1854 and is the world's longest running photography magazine.

foto8.com/new
A biannual print publication and online magazine of photojournalism and documentary photography.

fulltable.com
An enormous online resource of visual storytelling.

icp.org
The International Centre of Photography has an extensive online resource including The Photographers Lecture Series Archive.

lensculture.com
An online magazine celebrating international photography.

magnumphotos.com
Founded in 1947 Magnum Photos is an international photographic cooperative owned by its members.

photoworks.org.uk
Photoworks commissions and publishes contemporary photography in the south east of England.

portfoliocatalogue.com
This site shows contemporary photography in Britain, it has been discontinued in print but the online resource covers details of past issues.

seesawmagazine.com
An online photography magazine.

source.ie
A quarterly magazine of contemporary photography with an online archive.

Featured photographers

amber-online.com/exhibitions/weegee-collection

andrewrobinsonphotography.com

betsiegenou.com

brittaphotography.com

charleymurrell.com

chiaratocci.com

christinehurst.co.uk

commercegraphics.com/ba.html
(Berenice Abbott)

eleanorkelly.com

emmablaneyphotography.com

gagosian.com/artists/gregory-crewdson

henricartierbresson.org

jamiesinclairphotography.blogspot.com

janetbordeninc.com/artists/barney
(Tina Barney)

jillcole.com

katenolan.co.uk

keithmorrisphoto.co.uk

laurapannack.com

magnumphotos.com/evearnold

magnumphotos.com/robertcapa

mariashort.co.uk

markpower.co.uk

michaelhughesphotography.com

michellesank.com

mothers-of-invention.com
(Kim Sweet)

mr-lee-catcam.de
(Jürgen Perthold)

newshatavakolian.com

olenaslyesarenko.com

pangeafoto.com
(José A. Navarro)

paulfuscophoto.com

pollybraden.com

rchivers.co.uk

richardrowland.co.uk

robertmann.com/artists/southam/about.html
(Jem Southam)

sebakurtis.com

shaleentemple.com

shootbacknow.org

simoncarruthers.org.uk

stuartgriffiths.net

susanderges.com

susanmeiselas.com

tarynsimon.com

tomstoddart.com

trevwilliams.com

vosoughnia.com

wix.com/eobphoto/eob
(Emma O'Brien)

wix.com/mslydiaoc/photo
(Lydia O'Connor)

Front cover and pages 60–63: Images from 'Homeless Ex-Service' © Stuart Griffiths.

Page 8: Mother of Martyrs © Newsha Tavakolian.

Page 11: Sandy Springs Bank Robbery (c. 1920). Courtesy of National Photo Company Collection (Library of Congress).

Page 15: Gladys, East London, South Africa, 2009. Image courtesy of artist, Shaleen Temple.

Page 16: Untitled, 1998–2002 © Gregory Crewdson. Courtesy Gagosian Gallery.

Page 18–19: Untitled © Phil Glendinning.

Pages 21 and 23: Nan and Dad © Tim Mitchell.

Page 25: Josh and Luke and Bronwyn from 'Young Carers' © Michelle Sank.

Page 27: Dr Feelgood © The estate of Keith Morris. keithmorrisphoto.co.uk.

Page 29: Sandinistas at the Walls of the Esteli National Guard Headquarters. 1979 © Susan Meiselas. Courtesy of Magnum Photos.

Pages 30–31: Images from 'Pavilion Unseen' © Michael C. Hughes.

Page 32: Family Burial Chambers © Mehdi Vosoughnia.

Pages 34–37: Untitled images © Richard Rowland.

Page 43: Images from 'Constructed Childhoods' © Charley Murrell Photography, 2010.

Page 44: Images from 'China Between' © Polly Braden.

Page 47: Cuba. Havana. Bar Girl in a Brothel in the Red Light District. 1954. © Eve Arnold. Courtesy of Magnum Photos.

Page 48–49: Images from 'Pickled' © Olena Slyesarenko, 2008.

Pages 50–52: Images from 'Red River' © Jem Southam.

Pages 56–57: Angel, Bubles, Furniture and Gazebo © Seba Kurtis.

Page 58: Summer's Bounty © Ray Fowler LRPS.

Pages 68–69: Images from 'The Bedrooms' © Emma O'Brien, 2010.

Page 71: Untitled from the series 'Neither' © Kate Nolan.

Page 72: News-stand; 32nd Street and Third Avenue. Nov. 19, 1935 © 2008 Commerce Graphics Ltd., Inc.

Pages 75–76: Images from 'Shootback' © Peter Ndolo/Shootback, Saidi Hamisi/Shootback.

Page 79: A Child Cries as he is Fed by an Aid Worker in the Feeding Centre at Ajiep, Southern Sudan, During the 1998 Famine © Tom Stoddart. Courtesy of Getty Images.

Page 81 and 142: Images from 'Life after Zog and Other Stories' © Chiara Tocci, 2010.

Page 83: The First Wave of American Troops Lands at Dawn. June 6th, 1944. Robert Capa © International Center of Photography. Courtesy of Magnum Photos.

Pages 84–85: Images from 'Cat's eye view' © Mr. Lee.

Page 87: Images from 'Constricted Reality' © Jamie Sinclair, 2009.

Page 89: Madelaine and Sam © Laura Pannack, 2010.

Pages 91–93: Images from 'The King Alfred' series © Simon Carruthers.

Page 96: 'Sunday New York Times, 1982' © Tina Barney, courtesy Janet Borden, Inc.

Pages 99–100: 'Full Circle' © Susan Derges.

Page 103: Image from 'Birds' © Jill Cole/Millenium Images Ltd.

Pages 104–105: 'Trashumantes' © José Navarro Photography.

Page 107: Birmingham 28 June, 2005, London 1 July, 2005 and Long Island 20 August, 2003 © Barbara Taylor.

Page 108 and 148: Máithreacha Agus Inionacha, Fervor Forgotten, Snaith '09. © Laura Mukabaa.

Page 111: Delhi. 1948. The Cremation of Gandhi on the Banks of the Sumna River. © Henri Cartier-Bresson. Courtesy of Magnum Photos.

Page 112: Untitled (The Watermill, Korana) 2010. From the series 'Vrzji Vrt (The Devil's Garden)'. © Eleanor Kelly, 2010.

Page 113: Caroline from 'Derry Road' © Lydia O'Connor, 2010.

Pages 114–117: Untitled © Kim Sweet.

Page 120: Untitled from 'The Consumed' © Christine Hurst Photography.

Pages 123–125: Images from 'The Spectre of an Impossible Desire' © Emma Blaney, 2010.

Page 131: Radio City and 5th Avenue, New York © Jane Stoggles.

Page 130: Sakura N-24 2002 © Risaku Suzuki. Courtesy of Gallery Koyanagi.

Page 135: USA. RFK Funeral Train. USA. 1968. Robert Kennedy funeral train. © Paul Fusco. Courtesy of Magnum Photos.

Pages 136–139: Rideau, Soucoupe, Volets and Noix © Betsie Genou.

Page 145: Polar Bear, Bremerhaven Zoo © Britta Jaschinski.

Page 146: Dogs Will be Dogs. Photographer: Britta Jaschinski. Client: Dogs Trust. Agency: Ogilvy & Mather.

Page 149: Heaven and Hell © Andrew Robinson Photography, 2008. Models, Oscar Jeffery and Zubeida Dasgupta.

Page 151: The Shipping Forecast GB. England. Scarborough. Tyne. Sunday 25 July 1993. West or southwest 3 or 4 increasing 5 or 6. Showers. Good. From 'The Shipping Forecast' series 1993–96.' © Mark Power. Courtesy of Magnum Photos.

Page 152: The Critic © Weegee (Arthur Fellig)/International Center of Photography. Courtesy Getty Images.

Page 155: U.S. Customs and Border Protection, Contraband Room John F. Kennedy International Airport, Queens, New York' © 2007/2011 Taryn Simon. Courtesy Gagosian Gallery/Steidl.

Page 156: The Soldier © Barney Craig, 2010.

Page 158: Untitled © Emily Watts, 2009.

Page 159: Untitled © Rhiannon Ellis.

Pages 160–161: Images from 'The Allotment, Tenantry Down Road, Brighton' © Mike Fearey.

Pages 162–165: Images from 'Uncertainty' and 'Collapsing the Wave Function' © Trevor Williams.

Page 168: Greenham Common, Missile Silos, August 2007 © Richard Chivers.

All other photographs and images are courtesy of the author, Maria Short: mariashort.co.uk

Index

Compiled by Indexing Specialists (UK) Ltd

Acknowledgements

To all my colleagues and students at the University of Brighton: their integrity, humanity, enthusiasm and commitment to the professional practice of the Arts make them a joy and privilege to work with.

To my dear friend Dr Chris Mullen, for his continued insightful support, wise words of encouragement and critical expertise throughout my career.

To my valued clients for providing their many, diverse and interesting briefs.

To my treasured friends and all those who have been involved in my self-directed projects over the years; who have generously given me their time, practical assistance, access to resources and belief in my work.

To all the talented contributors, and Georgia Kennedy and Brian Morris at AVA with whom I have greatly enjoyed working.

To my mentor in life Daisaku Ikeda.

To my wonderful parents, Dorothy Leucha Hine and Ian Ernest Short.

BASICS
CREATIVE PHOTOGRAPHY

Lynne Elvins
Naomi Goulder

Working with ethics

Publisher's note

The subject of ethics is not new, yet its consideration within the applied visual arts is perhaps not as prevalent as it might be. Our aim here is to help a new generation of students, educators and practitioners find a methodology for structuring their thoughts and reflections in this vital area.

AVA Publishing hopes that these **Working with ethics** pages provide a platform for consideration and a flexible method for incorporating ethical concerns in the work of educators, students and professionals. Our approach consists of four parts:

The **introduction** is intended to be an accessible snapshot of the contemporary ethical landscape, both in terms of historical development and current dominant themes.

The **framework** positions ethical consideration into four areas and poses questions about the practical implications that might occur. Marking your response to each of these questions on the scale shown will allow your reactions to be further explored by comparison.

The **case study** sets out a real project and then poses some ethical questions for further consideration. This is a focus point for a debate rather than a critical analysis, so there are no predetermined right or wrong answers.

A selection of **further reading** for you to consider areas of particular interest in more detail.

Ethical: aware-ness/ reflect-ion/ debate

Working with ethics

Introduction

Ethics is a complex subject that interlaces the idea of responsibilities to society with a wide range of considerations relevant to the character and happiness of the individual. It concerns virtues of compassion, loyalty and strength, but also of confidence, imagination, humour and optimism. As introduced in ancient Greek philosophy, the fundamental ethical question is: *what should I do?* How we might pursue a 'good' life not only raises moral concerns about the effects of our actions on others, but also personal concerns about our own integrity.

In modern times the most important and controversial questions in ethics have been the moral ones. With growing populations and improvements in mobility and communications, it is not surprising that considerations about how to structure our lives together on the planet should come to the forefront. For visual artists and communicators, it should be no surprise that these considerations will enter into the creative process.

Some ethical considerations are already enshrined in government laws and regulations or in professional codes of conduct. For example, plagiarism and breaches of confidentiality can be punishable offences. Legislation in various nations makes it unlawful to exclude people with disabilities from accessing information or spaces. The trade of ivory as a material has been banned in many countries. In these cases, a clear line has been drawn under what is considered unacceptable.

But most ethical matters remain open to debate, among experts and lay-people alike, and in the end we have to make our own choices on the basis of our own guiding principles or values. Is it more ethical to work for a charity than for a commercial company? Is it unethical to create something that others find ugly or offensive?

Specific questions such as these may lead to other questions that are more abstract. For example, is it only effects on humans (and what they care about) that are important, or might effects on the natural world require attention too?

Is promoting ethical consequences justified even when it requires ethical sacrifices along the way? Must there be a single unifying theory of ethics (such as the Utilitarian thesis that the right course of action is always the one that leads to the greatest happiness of the greatest number), or might there always be many different ethical values that pull a person in various directions?

As we enter into ethical debate and engage with these dilemmas on a personal and professional level, we may change our views or change our view of others. The real test though is whether, as we reflect on these matters, we change the way we act as well as the way we think. Socrates, the 'father' of philosophy, proposed that people will naturally do 'good' if they know what is right. But this point might only lead us to yet another question: *how do we know what is right?*

You
What are your ethical beliefs?

Central to everything you do will be your attitude to people and issues around you. For some people, their ethics are an active part of the decisions they make every day as a consumer, a voter or a working professional. Others may think about ethics very little and yet this does not automatically make them unethical. Personal beliefs, lifestyle, politics, nationality, religion, gender, class or education can all influence your ethical viewpoint.

Using the scale, where would you place yourself? What do you take into account to make your decision? Compare results with your friends or colleagues.

Your client
What are your terms?

Working relationships are central to whether ethics can be embedded into a project, and your conduct on a day-to-day basis is a demonstration of your professional ethics. The decision with the biggest impact is whom you choose to work with in the first place. Cigarette companies or arms traders are often-cited examples when talking about where a line might be drawn, but rarely are real situations so extreme. At what point might you turn down a photographic project on ethical grounds and how much does the reality of having to earn a living affect your ability to choose?

Using the scale, where would you place a photographic project? How does this compare to your personal ethical level?

01 02 03 04 05 06 07 08 09 10

01 02 03 04 05 06 07 08 09 10

Your specifications
What are the impacts of your materials?

In relatively recent times, we are learning that many natural materials are in short supply. At the same time, we are increasingly aware that some man-made materials can have harmful, long-term effects on people or the planet. How much do you know about the materials that you use? Do you know where they come from, how far they travel and under what conditions they are obtained? When your photography or materials is no longer needed, will it be easy and safe to recycle? Will it disappear without a trace? Are these considerations your responsibility or are they beyond your control?

Using the scale, mark how ethical your material choices are.

Your creation
What is the purpose of your work?

Between you, your colleagues and an agreed brief, what will your creation achieve? What purpose will it have in society and will it make a positive contribution? Should your work result in more than commercial success or industry awards? Might your photography help save lives, educate, protect or inspire? Form and function are two established aspects of judging a photograph, but there is little consensus on the obligations of visual artists and communicators toward society, or the role they might have in solving social or environmental problems. If you want recognition for being the creator, how responsible are you for what you create and where might that responsibility end?

Using the scale, mark how ethical the purpose of your work is.

01 02 03 04 05 06 07 08 09 10

01 02 03 04 05 06 07 08 09 10

Working with ethics

One aspect of photography that raises an ethical dilemma is that of inherent truth or untruth in manipulating images, particularly with the use of digital cameras. Photographs have, arguably, always been manipulated and at best they represent the subjective view of the photographer in one moment of time. There has always been darkroom manipulation through retouching or double exposures, but these effects are far easier to produce digitally and harder to detect. In the past, the negative was physical evidence of the original, but digital cameras don't leave similar tracks.

While creative photography might not set out to capture and portray images with the same intent that documentary photography might, is there an inherent deception in making food look tastier, people appear better looking or resorts look more spacious and attractive? Does commercial image manipulation of this kind set out to favour the content in order to please, or is it contrary to public interest if it results in a purchase based on a photograph that was never 'the real thing'? How much responsibility should a photographer have when the more real alternative might not sell?

Bernarr Macfadden's *New York Evening Graphic* was dubbed 'the Porno Graphic' for its emphasis on sex, gossip and crime news. In the early 1920s, Macfadden had set out to break new ground and publish a newspaper that would speak the language of the average person. One of the paper's trademark features was the creation and use of the composograph. These were often scandalous photographic images that were made using retouched photo collages doctored to imply real situations. The most notorious use of the composograph was for the sensational Rhinelander divorce trial in 1925.

Wealthy New York socialite Leonard Kip Rhinelander married Alice Jones, a nursemaid and laundress he had fallen in love with. When word got out, it was one of high society's most shocking public scandals in generations. Not only was Alice a common maid, it was also revealed that her father was African American. After six weeks of pressure from his family, Rhinelander sued for divorce on the grounds that his wife had hidden her mixed-race origins from him. During the trial, Jones's attorney had requested that she strip to the waist as proof that her husband had clearly known all along that she was black.

Because the court had barred photographers from witnessing this display, the *Evening Graphic* staged a composograph of Jones displaying her nude torso to the all-white jury. It was made by combining separate photographs of all the people involved and resizing them to proportion. Harry Grogin, the assistant art director, also arranged for an actress to be photographed semi naked in a pose that he imagined Jones would have taken. Grogin is said to have used 20 separate photos to arrive at the one compiled shot, but the resulting picture was believable. The *Evening Graphic's* circulation rose from 60,000 to several hundred thousand after that issue.

Despite healthy sales, the paper struggled financially because its trashy reputation did not attract advertisers. In spite of the financial position, Macfadden continued to plough his own money into the venture. The paper lasted just eight years – from 1924 to 1932 – and Macfadden is said to have lost over USD$10 million in the process. But the sensationalism, nudity and inventive methods of reporting set a model for tabloid journalism as we know it today.

Is producing fake images of real situations unethical?

Is it unethical to produce images based on sensationalism and nudity?

Would you have created composographs for the *Evening Graphic*?

'A photograph is a secret about a secret. The more it tells you the less you know.'

Diane Arbus

AIGA
Design Business and Ethics
2007, AIGA

Eaton, Marcia Muelder
Aesthetics and the Good Life
1989, Associated University Press

Ellison, David
Ethics and Aesthetics in European Modernist Literature:
From the Sublime to the Uncanny
2001, Cambridge University Press

Fenner, David E W (Ed)
Ethics and the Arts: An Anthology
1995, Garland Reference Library of Social Science

Gini, Al and Marcoux, Alexie M
Case studies in Business Ethics
2005, Prentice Hall

McDonough, William and Braungart, Michael
Cradle to Cradle:
Remaking the Way We Make Things
2002, North Point Press

Papanek, Victor
Design for the Real World: Making to Measure
1972, Thames & Hudson

United Nations Global Compact
The Ten Principles
www.unglobalcompact.org/AboutTheGC/TheTenPrinciples/index.html